THE ILLUSTRATED
BOOK *of* GENESIS

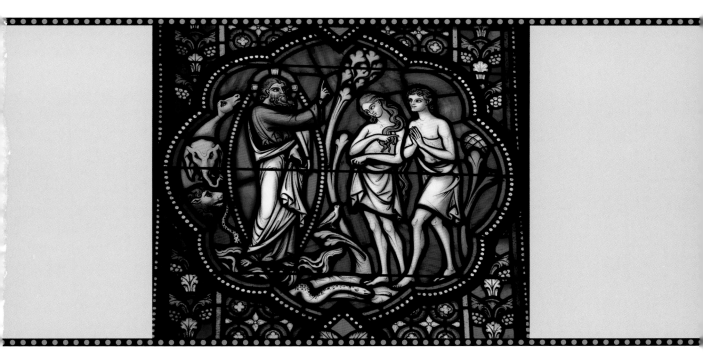

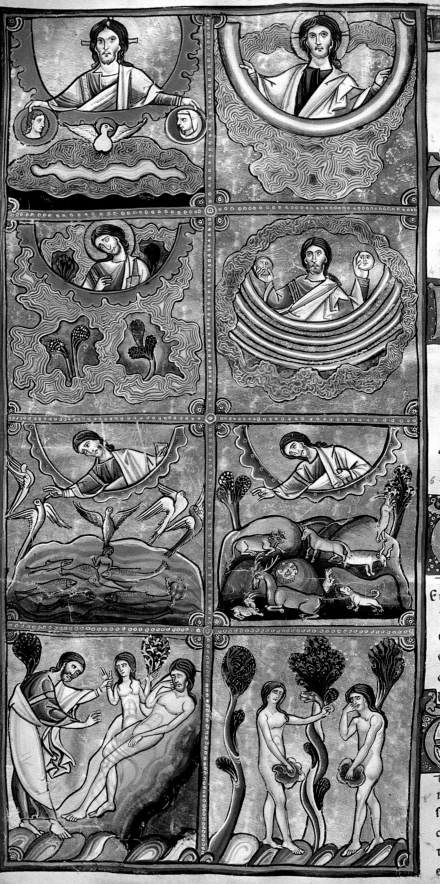

creauit ds celum ⁊ tram; Terra aute erat inan
et uacua. ⁊tenebre erant sup facie abyssi ⁊ sps
ferebatur sup aquas; Dixitq; ds; Fiat lux; Et fact
lux; Et uidit deus lucem qd eet bona ⁊diuisit l
a tenebris. apellauitq; luce diem ⁊tenebras noct
factumq; e̅. uespe ⁊mane: dies unus; II

Dixit quoq; ds; Fiat firmamtu in medi
aquaru. et diuidat aquas ab aquis; E
fecit ds firmamentu: diuisitq; aquas que erant
firmamto. ab his que erant sup firmamtu;
factum e̅. ita; Uocauitq; ds firmamtu celu. et f
tum e̅. uespere ⁊mane dies secundus; III

Dixit uero deus; Congregent aque que s
celo sunt in locu unu. et appareat arida
factumq; e̅. ita; Et uocauit ds aridam
terram. congregationesq; aquaru appellauit
maria; Et uidit ds qd eet bonum: et ait; Ger
net tra herbam uirente et faciente sem ⁊lignu
pomiferu faciens fructum iuxta genus suu. ⁊
sem in semet ipso sit sup tram; Et factu est ita;
ptulit tra herbam uirente ⁊afferente sem iuxt
genus suu. lignumq; faciens fructu. et habens
qdq; sementem secdm specie suam; Et uidit ds
eet bonu: factuq; est uespe et mane dies t̅cius;

Dix aute ds; Fiant luminaria in firm
mento celi. ut diuidant die ac nocte
et sint in signa ⁊tempora ⁊dies ⁊an
⁊luceant in firmamto celi. ⁊illuminent tra
et factum e̅. ita; Fecitq; ds duo magna luminar
luminare mai ut p eet diei ⁊luminare mi ut p
eet noct. ⁊stellas. et posuit eas ds in firmamt
celi ut lucerent sup tram ⁊p eent diei ac nocti: et
diuiderent luce ac tenebras; Et uidit ds qd eet
bonu. ⁊factu est uespe ⁊mane dies quart;

Dixit etiam ds; Producant aque reptile
anime uiuentis ⁊uolatile sup tram. su
firmamto celi; Creauitq; ds cete grandi
⁊omem anima uiuente atq; motabile. qua pdu
rant aque in species suas. ⁊ome uolatile secdm g
suum; Et uidit ds qd eet bonum: benedixitq; eis ce
cens; Crescite ⁊multiplicamini ⁊replete aquas
maris. auesq; multiplicent sup tram; Et factu
est uespe et mane: dies quintus; VI

THE ILLUSTRATED
BOOK *of* GENESIS

CHARTWELL
BOOKS, INC.

A QUARTO BOOK

Published in 2014 by
Chartwell Books, Inc.
A Division of Book Sales, Inc.
276 Fifth Avenue Suite 206
New York, New York 10001
USA

Copyright © 2014 Quarto Inc.

ISBN: 978-0-7858-3100-6

Conceived, designed, and produced by
Quarto Publishing plc
The Old Brewery
6 Blundell Street
London N7 9BH

QUA: IBG

Editor & designer: Michelle Pickering
Proofreader: Claire Waite Brown
Indexer: Ann Barrett
Art director: Caroline Guest
Creative director: Moira Clinch
Publisher: Paul Carslake

Color separation by Cypress
Colours (HK) Ltd, Hong Kong
Printed by 1010 Printing
International Ltd, China

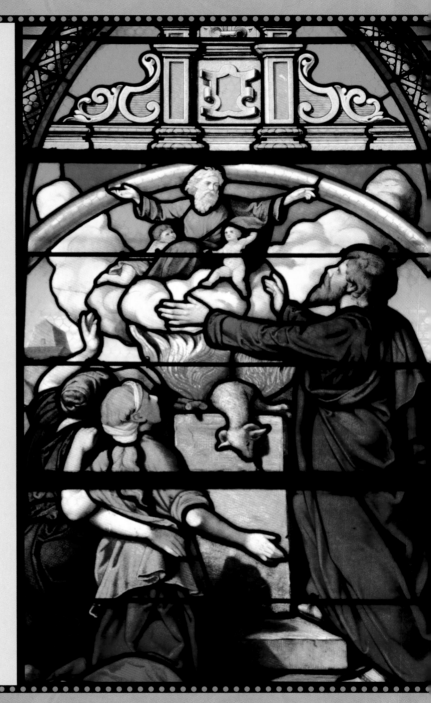

PAGE 1: Expulsion of Adam and Eve from the Garden of Eden (*Stained-glass window in the Cathedral of St. Michael and St. Gudula in Brussels, Belgium, by Jean-Baptiste Capronnier, 19th century*)

PAGE 2: Creation of the World (*Illuminated manuscript page from the Bible of Souvigny, French School, 12th century*)

ABOVE: God's Covenant with Noah after the Flood (*Stained-glass window in the Church of Saint-Pierre-Saint-Paul in Les Mureaux, France, 1895–1906*)

CONTENTS

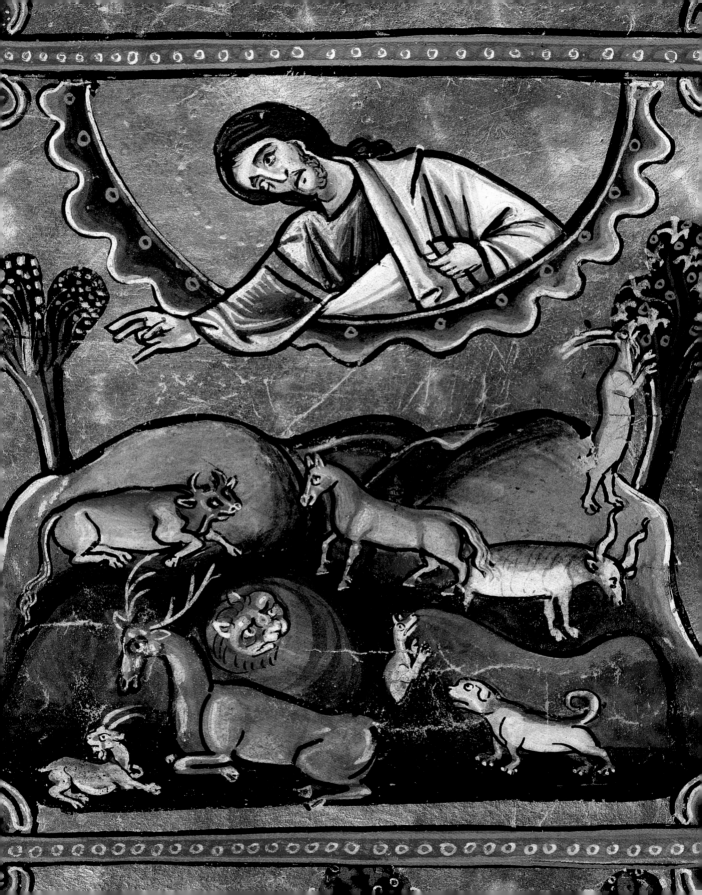

INTRODUCTION

The first book of the Old Testament is entitled "The First Book of Moses, Commonly Called Genesis." The first five books, known as the Pentateuch or Torah, are traditionally attributed to Moses, but they are in fact an anonymous work. The name Genesis comes from the Greek word for "origin." In the Hebrew Bible, the book of Genesis is named after its first word, *Breshit*, meaning "In the beginning."

The first eleven chapters of Genesis contain stories that explain the world as it is. It is the creation of an all-powerful God, who has fashioned human beings in his own image to master and care for the world. The stories explain how human failure and its dreadful consequences come to be in the world, though the loving God is always ready to forgive. The imagery is very similar to that of Babylonian origin legends, but the picture of God and the position of human beings in the world is very different. Like many origin myths, these stories are historical in form; however, crucially they guide the readers to an understanding of the present state of affairs.

There follows a folk history, the story of the family of nomads who would later become the nucleus of the Israelites, bringing God's blessing to all nations. It is an epic story of three heroes—the patriarchs Abraham, Isaac, and Jacob—comprised of family adventures, heroic and unheroic episodes, and incidents explaining names and customs. Through it all runs the thread of the promise to Abraham of numberless descendants and a Promised Land that they would possess as their own. Finally comes the epic story of Joseph, the hero who brought his family down to Egypt, where they would settle for hundreds of years.

The stories of Abraham and his family were handed down from generation to generation before finally being recorded, perhaps as late as the 4th century B.C.E. Biblical scholars have discerned three sets of characteristics in Genesis, and identify these with three sources or authors. The Yahwist uses the name "Yahweh" or "the LORD" for God, and presents a warm and affectionate image of God. The Elohist uses the common word "Elohim" for God, and shows a God more distant and concerned with morality. The priestly author supplements these two with stories about the rituals and religious customs of the Jews.

The many fascinating stories in Genesis have inspired innumerable works of art over the centuries. This book features the complete text of Genesis and is illustrated with a selection of beautiful works of art, from Old Master paintings and frescoes to stained glass and illuminations. Note that the titles by which these artworks are known generally use the commonplace spellings of biblical characters' names, and these may differ from the spellings used in the biblical text—for example, Rebecca in place of Rebekah.

God Creating the Animals

French School
12TH CENTURY

This richly illuminated detail from a page of the Bible of Souvigny shows God creating the animals that would inhabit the land. According to Genesis, this took place on the sixth day of the creation of the universe.

CHAPTERS 1–5

God creates the universe over the course of six days, then rests on the seventh. God puts the first man and woman, Adam and Eve, into the Garden of Eden, but warns them not to eat from the Tree of the Knowledge of Good and Evil or they will become mortal. When they do so, God curses them and expels them from Eden so that they cannot gain immortality by eating from the Tree of Life. God sends Cain, one of Adam and Eve's sons, into exile after Cain murders his brother Abel. The section ends with a genealogy from Adam to Noah.

CHAPTER 1

In the beginning, God created the heavens and the earth. ² The earth was formless and empty. Darkness was on the surface of the deep and God's Spirit was hovering over the surface of the waters.

³ God said, "Let there be light," and there was light. ⁴ God saw the light, and saw that it was good. God divided the light from the darkness. ⁵ God called the light "day", and the darkness he called "night". There was evening and there was morning, the first day.

⁶ God said, "Let there be an expanse in the middle of the waters, and let it divide the waters from the waters." ⁷ God made the expanse, and divided the waters which were under the expanse from the waters which were above the expanse; and it was so. ⁸ God called the expanse "sky". There was evening and there was morning, a second day.

⁹ God said, "Let the waters under the sky be gathered together to one place, and let the dry land appear"; and it was so. ¹⁰ God called the dry land "earth", and the gathering together of the waters he called "seas". God saw that it was good. ¹¹ God said, "Let the earth yield grass, herbs yielding seeds, and fruit trees bearing fruit after their kind, with their seeds in it, on the earth"; and it was so. ¹² The earth yielded grass, herbs yielding seed after their kind, and trees bearing fruit, with their seeds in it, after their kind; and God saw that it was good. ¹³ There was evening and there was morning, a third day.

¹⁴ God said, "Let there be lights in the expanse of sky to divide the day from the night; and let them be for signs to mark seasons, days, and years; ¹⁵ and let them be for lights in the expanse of sky to give light on the earth"; and it was so. ¹⁶ God made the two great lights: the greater light to rule the day, and the lesser light to rule the night. He also made the stars. ¹⁷ God set them in the expanse of sky to give light to the earth, ¹⁸ and to rule over the day and over the night, and to divide the light from the darkness. God saw that it was good. ¹⁹ There was evening and there was morning, a fourth day.

²⁰ God said, "Let the waters abound with living creatures, and let birds fly above the earth in the open expanse of sky." ²¹ God created the large sea creatures and every living creature that moves, with which the waters swarmed, after their kind, and every winged bird after its kind. God saw that it was good. ²² God blessed them, saying, "Be fruitful, and multiply, and fill the waters in the seas, and let birds multiply on the earth." ²³ There was evening and there was morning, a fifth day.

²⁴ God said, "Let the earth produce living creatures after their kind, livestock, creeping things, and animals of the earth after their kind"; and it was so. ²⁵ God made the animals of the earth after their kind, and the livestock after their kind, and everything that creeps on the ground after its kind. God saw that it was good.

²⁶ God said, "Let us make man in our image, after our likeness: and let them have dominion over the fish of the sea, and over the birds of the sky, and over the livestock, and over all the earth, and over every creeping thing that creeps on the earth." ²⁷ God created man in his own image. In God's image he created him; male and female he created them. ²⁸ God blessed them. God said to them, "Be fruitful, multiply, fill the earth, and subdue it. Have dominion over the fish of the sea, over the birds of the sky, and over every living

God said, "Let the earth produce living creatures after their kind, livestock, creeping things, and animals of the earth after their kind"; and it was so.

Genesis 1:24

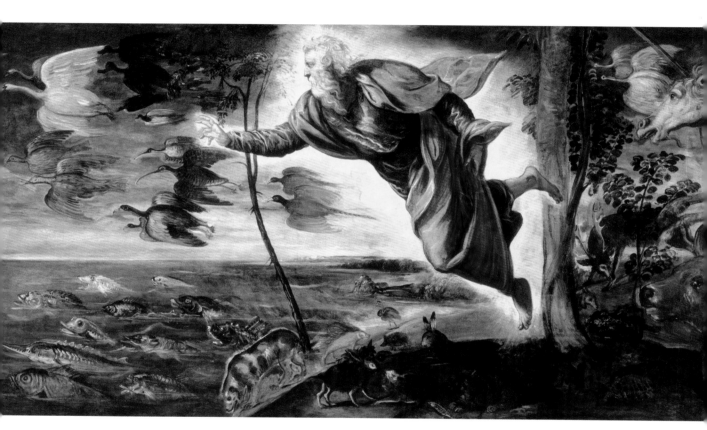

The Creation of the Animals

Jacopo Tintoretto
c. 1550

According to Genesis, God created the heavens and the earth over the course of four days, then on the fifth day he populated the seas and skies with creatures and birds. On the sixth day he created the animals of the land and, finally, the first two human beings, Adam and Eve. God instructed all of the living creatures he created to be fruitful, multiply, and cover the earth.

thing that moves on the earth." **29** God said, "Behold, I have given you every herb yielding seed, which is on the surface of all the earth, and every tree, which bears fruit yielding seed. It will be your food. **30** To every animal of the earth, and to every bird of the sky, and to everything that creeps on the earth, in which there is life, I have given every green herb for food"; and it was so.

31 God saw everything that he had made, and, behold, it was very good. There was evening and there was morning, a sixth day.

CHAPTER 2

The heavens, the earth, and all their vast array were finished. **2** On the seventh day God finished his work which he had done; and he rested on the seventh day from all his work which he had done. **3** God blessed the seventh day, and made it holy, because he rested in it from all his work of creation which he had done.

4 This is the history of the generations of the heavens and of the earth when they were created, in the day that the LORD God [*the Hebrew name YHWH, or Yahweh, is rendered as "LORD," written in capital letters, in most Christian Bible translations*] made the earth and the heavens. **5** No plant of the field was yet in the earth, and no herb of the field had yet sprung up; for the LORD God had not caused it to rain on the earth. There was not a man to till the ground, **6** but a mist went up from the earth, and watered the whole surface of the ground. **7** The LORD God formed man from the dust of the ground, and breathed into his nostrils the breath of life; and man became a living soul. **8** The LORD God planted a garden eastward, in Eden, and there he put the man whom he had formed. **9** Out of the ground the LORD God made every tree to grow that is pleasant to the sight, and good for food, including the tree of life in the middle of the garden and the tree of the knowledge of good and evil. **10** A river went out of Eden to water the garden; and from there it was parted, and became the source of four rivers. **11** The name of the first is Pishon: it flows through the whole land of Havilah, where there is gold; **12** and the gold of that land is good. Bdellium [*aromatic resin*] and onyx stone are also there.

13 The name of the second river is Gihon. It is the same river that flows through the whole land of Cush. **14** The name of the third river is Hiddekel. This is the one which flows in front of Assyria. The fourth river is the Euphrates. **15** The LORD God took the man, and put him into the garden of Eden to cultivate and keep it. **16** The LORD God commanded the man, saying, "You may freely eat of every tree of the garden; **17** but you shall not eat of the tree of the knowledge of good and evil; for in the day that you eat of it, you will surely die."

18 The LORD God said, "It is not good for the man to be alone. I will make him a helper comparable to him." **19** Out of the ground the LORD God formed every animal of the field, and every bird of the sky, and brought them to the man to see what he would call them. Whatever the man called every living creature became its name. **20** The man gave names to all livestock, and to the birds of the sky, and to every animal of the field; but for man there was not found a helper comparable to him. **21** The LORD God caused the man to fall into a deep sleep. As the man slept, he took one of his ribs, and closed up the flesh in its place. **22** The LORD God made a woman from the rib which he had taken from the man, and brought her to the man. **23** The man said, "This is now bone of my bones, and flesh of my flesh. She will be called 'woman', because she was taken out of Man." **24** Therefore a man will leave his father and his mother, and will join with his wife, and they will be one flesh. **25** The man and his wife were both naked, and they were not ashamed.

CHAPTER 3

Now the serpent was more subtle than any animal of the field which the LORD God had made. He said to the woman, "Has God really said, 'You shall not eat of any tree of the garden?'"

2 The woman said to the serpent, "We may eat fruit from the trees of the garden, **3** but not the fruit of the tree which is in the middle of the garden. God has said, 'You shall not eat of it. You shall not touch it, lest you die.'"

4 The serpent said to the woman, "You won't surely die, **5** for God knows that in the

day you eat it, your eyes will be opened, and you will be like God, knowing good and evil."

6 When the woman saw that the tree was good for food, and that it was a delight to the eyes, and that the tree was to be desired to make one wise, she took some of its fruit, and ate; and she gave some to her husband with her, and he ate it, too. **7** Their eyes were opened, and they both knew that they were naked. They sewed fig leaves together, and made coverings for themselves. **8** They heard the LORD God's voice walking in the garden in the cool of the day, and the man and his wife hid themselves from the presence of the LORD God among the trees of the garden.

9 The LORD God called to the man, and said to him, "Where are you?"

10 The man said, "I heard your voice in the garden, and I was afraid, because I was naked; and I hid myself."

11 God said, "Who told you that you were naked? Have you eaten from the tree that I commanded you not to eat from?"

12 The man said, "The woman whom you gave to be with me, she gave me fruit from the tree, and I ate it."

13 The LORD God said to the woman, "What have you done?"

The woman said, "The serpent deceived me, and I ate."

14 The LORD God said to the serpent,
"Because you have done this,
 you are cursed above all livestock,
 and above every animal of the field.
You shall go on your belly
 and you shall eat dust
 all the days of your life.
15 I will put hostility between
 you and the woman,
 and between your offspring
 and her offspring.
He will bruise your head,
 and you will bruise his heel."
16 To the woman he said,
"I will greatly multiply your pain
 in childbirth.
 In pain you will bear children.
Your desire will be for your husband,
 and he will rule over you."
17 To Adam he said, "Because you have listened to your wife's voice, and ate from the tree, about which I commanded you, saying, 'You shall not eat of it':

The ground is cursed for your sake.
 You will eat from it with much labor
 all the days of your life.
18 It will yield thorns and thistles to you;
 and you will eat the herb of the field.
19 By the sweat of your face
 will you eat bread
until you return to the ground,
 for out of it you were taken.
For you are dust,
 and to dust you shall return."
20 The man called his wife Eve because she would be the mother of all the living. **21** The LORD God made coats of animal skins for Adam and for his wife, and clothed them.

22 The LORD God said, "Behold, the man has become like one of us, knowing good and evil. Now, lest he reach out his hand, and also take of the tree of life, and eat, and live forever..." **23** Therefore the LORD God sent him out from the garden of Eden, to till the ground from which he was taken. **24** So he drove out the man; and he placed cherubim [*angelic creatures*] at the east of the garden of Eden, and a flaming sword which turned every way, to guard the way to the tree of life.

Adam and Eve

Lucas Cranach the Elder
1526

Standing in the Garden of Eden surrounded by birds and animals, Eve is shown handing an apple from the Tree of the Knowledge of Good and Evil to Adam. The serpent that persuaded Eve to pick the fruit is entwined in the branches of the tree, watching Adam and Eve succumb to temptation.

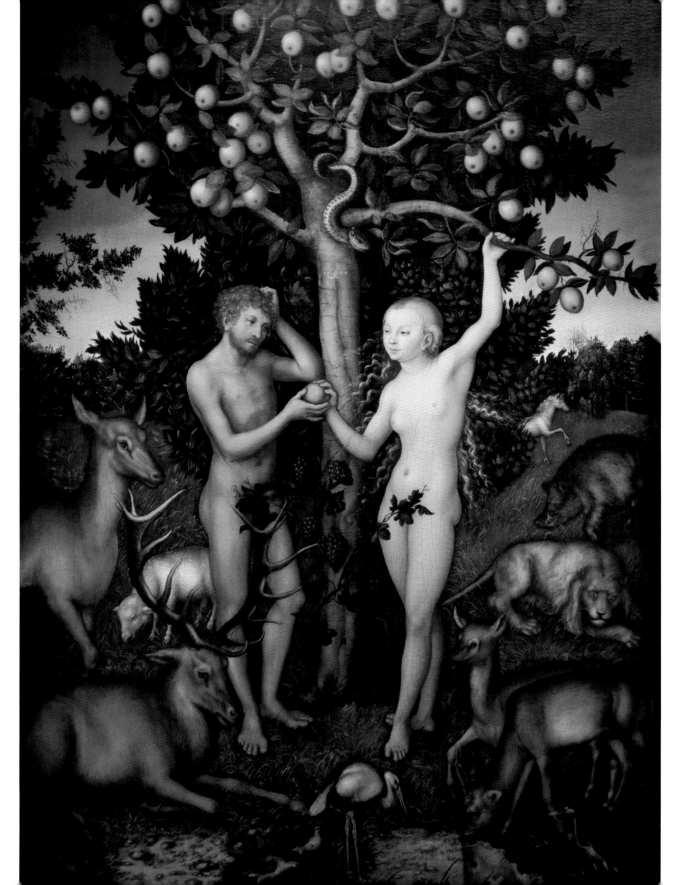

> *While they were in the field, Cain rose up against Abel, his brother, and killed him…The LORD said, "What have you done? The voice of your brother's blood cries to me from the ground. Now you are cursed because of the ground, which has opened its mouth to receive your brother's blood from your hand. From now on, when you till the ground, it won't yield its strength to you. You will be a fugitive and a wanderer in the earth."*

Genesis 4:8–12

CHAPTER 4

The man knew [*had sexual relations with*] Eve his wife. She conceived, and gave birth to Cain, and said, "I have gotten a man with the LORD's help." **2** Again she gave birth, to Cain's brother Abel. Abel was a keeper of sheep, but Cain was a tiller of the ground. **3** As time passed, Cain brought an offering to the LORD from the fruit of the ground. **4** Abel also brought some of the firstborn of his flock and of its fat. The LORD respected Abel and his offering, **5** but he didn't respect Cain and his offering. Cain was very angry, and the expression on his face fell. **6** The LORD said to Cain, "Why are you angry? Why has the expression of your face fallen? **7** If you do well, won't it be lifted up? If you don't do well, sin crouches at the door. Its desire is for you, but you are to rule over it." **8** Cain said to Abel, his brother, "Let's go into the field." While they were in the field, Cain rose up against Abel, his brother, and killed him.

9 The LORD said to Cain, "Where is Abel, your brother?"

He said, "I don't know. Am I my brother's keeper?"

10 The LORD said, "What have you done? The voice of your brother's blood cries to me from the ground. **11** Now you are cursed because of the ground, which has opened its mouth to receive your brother's blood from your hand. **12** From now on, when you till the ground, it won't yield its strength to you. You will be a fugitive and a wanderer in the earth."

13 Cain said to the LORD, "My punishment is greater than I can bear. **14** Behold, you have driven me out today from the surface of the ground. I will be hidden from your face, and I will be a fugitive and a wanderer in the earth. Whoever finds me will kill me."

15 The LORD said to him, "Therefore whoever slays Cain, vengeance will be taken on him sevenfold." The LORD appointed a sign for Cain, so that anyone finding him would not strike him.

16 Cain left the LORD's presence, and lived in the land of Nod, east of Eden. **17** Cain knew his wife. She conceived, and gave birth to Enoch. He built a city, and called the name of the city, after the name of his son, Enoch. **18** To Enoch was born Irad. Irad became the father of Mehujael. Mehujael became the

father of Methushael. Methushael became the father of Lamech. **19** Lamech took two wives: the name of the first one was Adah, and the name of the second one was Zillah. **20** Adah gave birth to Jabal, who was the father of those who dwell in tents and have livestock. **21** His brother's name was Jubal, who was the father of all who handle the harp and pipe. **22** Zillah also gave birth to Tubal Cain, the forger of every cutting instrument of brass and iron. Tubal Cain's sister was Naamah. **23** Lamech said to his wives,

"Adah and Zillah, hear my voice.
 You wives of Lamech, listen to
 my speech,
for I have slain a man for wounding me,
 a young man for bruising me.
24 If Cain will be avenged seven times,
 truly Lamech seventy-seven times."

25 Adam knew his wife again. She gave birth to a son, and named him Seth, saying, "for God has given me another child instead of Abel, for Cain killed him." **26** A son was also born to Seth, and he named him Enosh. At that time men began to call on the LORD's name.

CHAPTER 5

This is the book of the generations of Adam. In the day that God created man, he made him in God's likeness. **2** He created them male and female, and blessed them. On the day they were created, he named them "Man" [*the Hebrew word for man is "adam"*]. **3** Adam lived one hundred thirty years, and became the father of a son in his own likeness, after his image, and named him Seth. **4** The days of Adam after he became the father of Seth were eight hundred years, and he became the father of other sons and daughters. **5** All the days that Adam lived were nine hundred thirty years, then he died.

6 Seth lived one hundred five years, then became the father of Enosh. **7** Seth lived after he became the father of Enosh eight hundred seven years, and became the father of other sons and daughters. **8** All of the days of Seth were nine hundred twelve years, then he died.

9 Enosh lived ninety years, and became the father of Kenan. **10** Enosh lived after he became the father of Kenan, eight hundred fifteen years, and became the father of other sons and daughters. **11** All of the days of Enosh were nine hundred five years, then he died.

12 Kenan lived seventy years, then became the father of Mahalalel. **13** Kenan lived after he became the father of Mahalalel eight hundred forty years, and became the father of other sons and daughters **14** and all of the days of Kenan were nine hundred ten years, then he died.

15 Mahalalel lived sixty-five years, then became the father of Jared. **16** Mahalalel lived after he became the father of Jared eight hundred thirty years, and became the father of other sons and daughters. **17** All of the days of Mahalalel were eight hundred ninety-five years, then he died.

18 Jared lived one hundred sixty-two years, then became the father of Enoch. **19** Jared lived after he became the father of Enoch eight hundred years, and became the father of other sons and daughters. **20** All of the days of Jared were nine hundred sixty-two years, then he died.

21 Enoch lived sixty-five years, then became the father of Methuselah. **22** After Methuselah's birth, Enoch walked with God for three hundred years, and became the father of more sons and daughters. **23** All the days of Enoch were three hundred sixty-five years. **24** Enoch walked with God, and he was not found, for God took him.

25 Methuselah lived one hundred eighty-seven years, then became the father of Lamech. **26** Methuselah lived after he became the father of Lamech seven hundred eighty-two years, and became the father of other sons and daughters. **27** All the days of Methuselah were nine hundred sixty-nine years, then he died.

28 Lamech lived one hundred eighty-two years, then became the father of a son. **29** He named him Noah, saying, "This one will comfort us in our work and in the toil of our hands, caused by the ground which the LORD has cursed." **30** Lamech lived after he became the father of Noah five hundred ninety-five years, and became the father of other sons and daughters. **31** All the days of Lamech were seven hundred seventy-seven years, then he died.

32 Noah was five hundred years old, then Noah became the father of Shem, Ham, and Japheth.

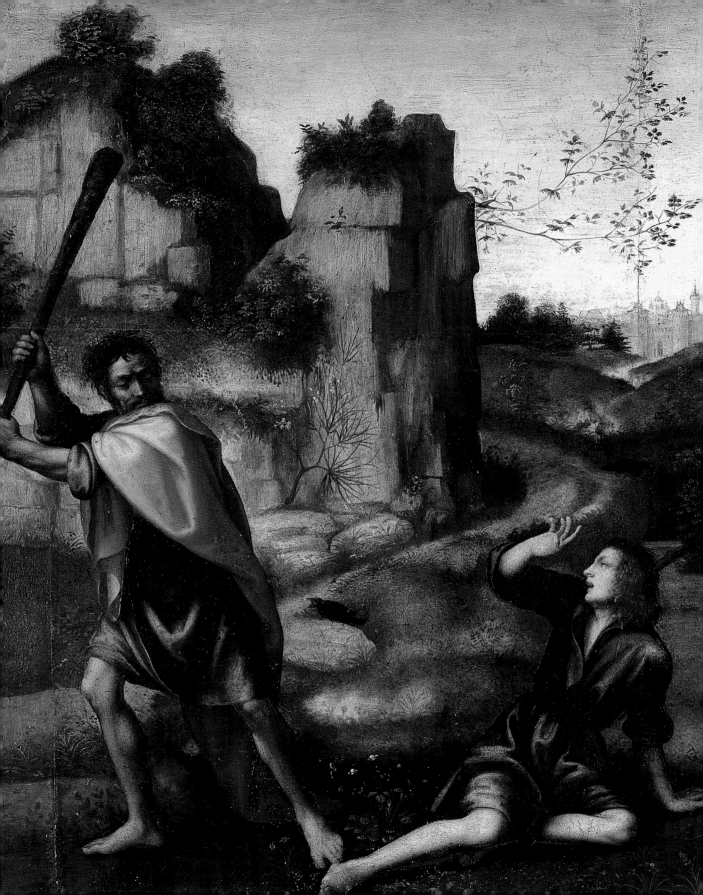

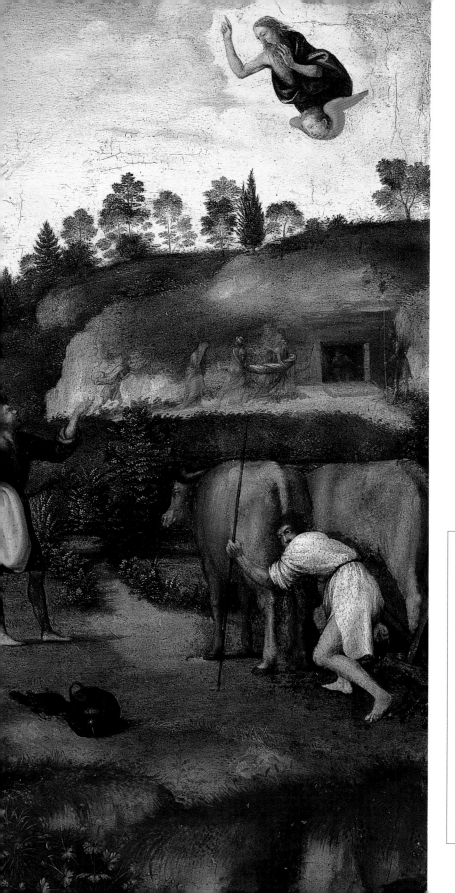

Cain Killing Abel

Mariotto Albertinelli
c. 1510–15

When Adam and Eve's sons Cain and Abel made offerings to God, God respected Abel's offering but not Cain's. In the left foreground of this painting a jealous and angry Cain raises a club to kill his brother Abel. At the top right, God sees Cain's actions and punishes him with exile, declaring that the ground would no longer yield its strength to him. The peasants struggling with oxen on the right may allude to this fate. In the background on the right, Abel's body is laid to rest in a hillside tomb.

CHAPTERS 6–11

Dismayed at the wickedness of humans, God decides to drown everyone except Noah, whom he orders to build a ship for himself, his family, and pairs of birds and animals. After disembarking a year later, Noah thanks God for their survival with a sacrifice. God promises that he will never again destroy the world with a flood, and says that the rainbow will be a reminder of this promise. Then Noah gets drunk and curses his grandson, Canaan. Noah's descendants construct the city and tower of Babel; God confuses their language, so that they scatter across the world.

CHAPTER 6

When men began to multiply on the surface of the ground, and daughters were born to them, **2** God's sons saw that men's daughters were beautiful, and they took any that they wanted for themselves as wives. **3** The LORD said, "My Spirit will not strive with man forever, because he also is flesh; so his days will be one hundred twenty years." **4** The Nephilim [*giants*] were in the earth in those days, and also after that, when God's sons came in to men's daughters and had children with them. Those were the mighty men who were of old, men of renown.

5 The LORD saw that the wickedness of man was great in the earth, and that every imagination of the thoughts of man's heart was continually only evil. **6** The LORD was sorry that he had made man on the earth, and it grieved him in his heart. **7** The LORD said, "I will destroy man whom I have created from the surface of the ground—man, along with animals, creeping things, and birds of the sky—for I am sorry that I have made them." **8** But Noah found favor in the LORD's eyes.

9 This is the history of the generations of Noah: Noah was a righteous man, blameless among the people of his time. Noah walked with God. **10** Noah became the father of three sons: Shem, Ham, and Japheth. **11** The earth was corrupt before God, and the earth was filled with violence. **12** God saw the earth, and saw that it was corrupt, for all flesh had corrupted their way on the earth.

13 God said to Noah, "I will bring an end to all flesh, for the earth is filled with violence through them. Behold, I will destroy them and the earth. **14** Make an ark [*a ship*] of gopher wood. You shall make rooms in the ark, and

shall seal it inside and outside with pitch. **15** This is how you shall make it. The length of the ark shall be three hundred cubits [*a cubit is the length from the tip of the middle finger to the elbow on a man's arm; about 18 in (46 cm)*], its width fifty cubits, and its height thirty cubits. **16** You shall make a roof in the ark, and you shall finish it to a cubit upward. You shall set the door of the ark in its side. You shall make it with lower, second, and third levels. **17** I, even I, do bring the flood of waters on this earth, to destroy all flesh having the breath of life from under the sky. Everything that is in the earth will die. **18** But I will establish my covenant with you. You shall come into the ark, you, your sons, your wife, and your sons' wives with you. **19** Of every living thing of all flesh, you shall bring two of every sort into the ark, to keep them alive with you. They shall be male and female. **20** Of the birds after their kind, of the livestock after their kind, of every creeping thing of the ground after its kind, two of every sort will come to you, to keep them alive. **21** Take with you some of all food that is eaten, and gather it to yourself; and it will be for food for you, and for them." **22** Thus Noah did. He did all that God commanded him.

CHAPTER 7

The LORD said to Noah, "Come with all of your household into the ark, for I have seen your righteousness before me in this generation. **2** You shall take seven pairs of every clean animal with you, the male and his female. Of the animals that are not clean, take two, the male and his female. **3** Also of the birds of the sky, seven and seven, male and female, to keep seed alive on

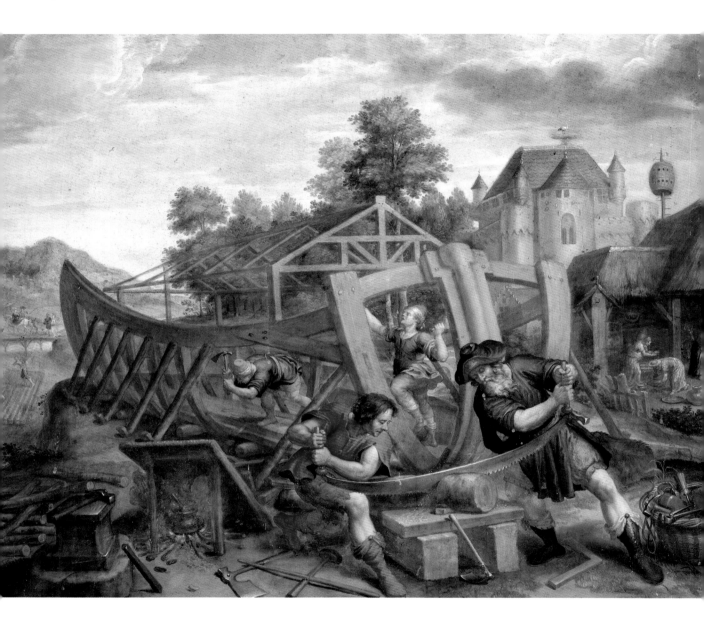

Building the Ark

Flemish School

17TH CENTURY

God decided to flood the earth because it was corrupt, but instructed the righteous Noah to build a large ship so that he and his family would be spared, along with pairs of each living creature. Here, Noah and his three sons, Shem, Ham, and Japheth, are building the ark according to God's detailed instructions. In the background on the right, the women of Noah's household prepare provisions to take aboard.

the surface of all the earth. ⁴ In seven days, I will cause it to rain on the earth for forty days and forty nights. I will destroy every living thing that I have made from the surface of the ground."

⁵ Noah did everything that the LORD commanded him.

⁶ Noah was six hundred years old when the flood of waters came on the earth. ⁷ Noah went into the ark with his sons, his wife, and his sons' wives, because of the floodwaters. ⁸ Clean animals, unclean animals, birds, and everything that creeps on the ground ⁹ went by pairs to Noah into the ark, male and female, as God commanded Noah. ¹⁰ After the seven days, the floodwaters came on the earth. ¹¹ In the six hundredth year of Noah's life, in the second month, on the seventeenth day of the month, on the same day all the fountains of the great deep were burst open, and the sky's windows were opened. ¹² It rained on the earth forty days and forty nights.

¹³ In the same day Noah, and Shem, Ham, and Japheth—the sons of Noah—and Noah's wife and the three wives of his sons with them, entered into the ark— ¹⁴ they, and every animal after its kind, all the livestock after their kind, every creeping thing that creeps on the earth after its kind, and every bird after its kind, every bird of every sort. ¹⁵ Pairs from all flesh with the breath of life in them went into the ark to Noah. ¹⁶ Those who went in, went in male and female of all flesh, as God commanded him; then the LORD shut him in. ¹⁷ The flood was forty days on the earth. The waters increased, and lifted up the ark, and it was lifted up above the earth. ¹⁸ The waters rose, and increased greatly on the earth; and the ark floated on the surface of the waters. ¹⁹ The waters rose very high on the earth. All the high mountains that were under the whole sky were covered. ²⁰ The waters rose fifteen cubits higher, and the mountains were covered. ²¹ All flesh died that moved on the earth, including birds, livestock, animals, every creeping thing that creeps on the earth, and every man. ²² All on the dry land, in whose nostrils was the breath of the spirit of life, died. ²³ Every living thing was destroyed that was on the surface of the ground, including man, livestock, creeping things, and birds of the sky. They were destroyed from the earth. Only Noah was left, and those who were with him in the ark. ²⁴ The waters flooded the earth one hundred fifty days.

CHAPTER 8

God remembered Noah, all the animals, and all the livestock that were with him in the ark; and God made a wind to pass over the earth. The waters subsided. ² The deep's fountains and the sky's windows were also stopped, and the rain from the sky was restrained. ³ The waters continually receded from the earth. After the end of one hundred fifty days the waters decreased. ⁴ The ark rested in the seventh month, on the seventeenth day of the month, on Ararat's mountains. ⁵ The waters receded continually until the tenth month. In the tenth month, on the first day of the month, the tops of the mountains were visible.

⁶ At the end of forty days, Noah opened the window of the ark which he had made, ⁷ and he sent out a raven. It went back and forth, until the waters were dried up from the earth. ⁸ He himself sent out a dove to see if the waters were abated from the surface of the ground, ⁹ but the dove found no place to rest her foot, and she returned into the ark to him, for the waters were on the surface of the whole earth. He put out his hand, and took her, and brought her to him into the ark. ¹⁰ He waited yet another seven days; and again he sent the dove out of the ark. ¹¹ The dove came back to him at evening and, behold, in her mouth was a freshly plucked olive leaf. So Noah knew that the waters were abated from the earth. ¹² He waited yet another seven days, and sent out the dove; and she didn't return to him anymore.

¹³ In the six hundred first year, in the first month, the first day of the month, the waters were dried up from the earth. Noah removed the covering of the ark, and looked. He saw that the surface of the ground was dried. ¹⁴ In the second month, on the twenty-seventh day of the month, the earth was dry.

¹⁵ God spoke to Noah, saying, ¹⁶ "Go out of the ark, you, your wife, your sons, and your sons' wives with you. ¹⁷ Bring out with you every living thing that is with you of all flesh, including birds, livestock, and every creeping thing that creeps on the earth, that they may breed abundantly in the earth, and be fruitful, and multiply on the earth."

¹⁸ Noah went out, with his sons, his wife, and his sons' wives with him. ¹⁹ Every animal, every creeping thing, and every bird, whatever

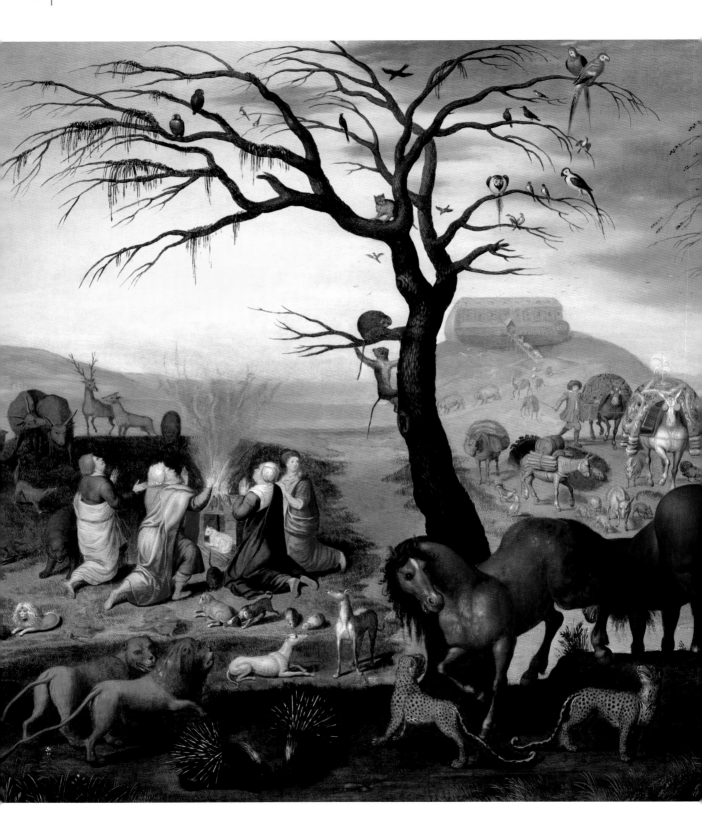

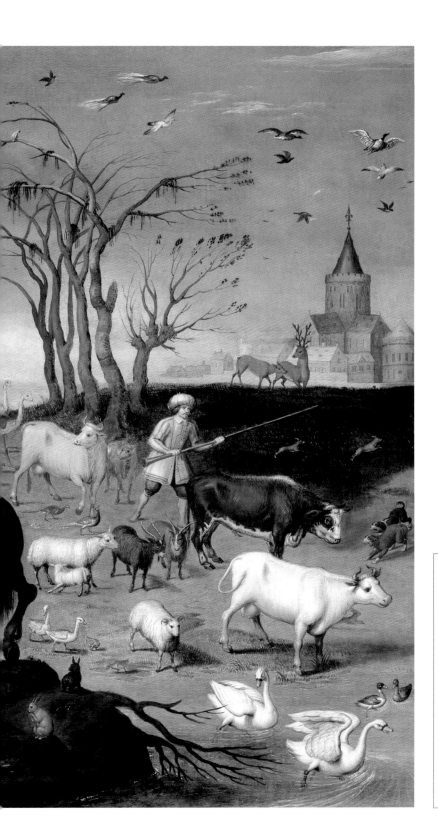

The Animals Leaving the Ark

Jacob Bouttats

c. 1700

Once the earth was dry after the flood, God told Noah to leave the ark. Here, the birds and animals can be seen leaving the ship and spreading out across the land. On the left, Noah and his family kneel around an altar at which they are making burnt offerings to God in thanks for their survival. In return, God agreed never to destroy the world with such a flood again.

moves on the earth, after their families, went out of the ark.

20 Noah built an altar to the LORD, and took of every clean animal, and of every clean bird, and offered burnt offerings on the altar. **21** The LORD smelled the pleasant aroma. The LORD said in his heart, "I will not again curse the ground any more for man's sake because the imagination of man's heart is evil from his youth. I will never again strike every living thing, as I have done. **22** While the earth remains, seed time and harvest, and cold and heat, and summer and winter, and day and night will not cease."

CHAPTER 9

God blessed Noah and his sons, and said to them, "Be fruitful, multiply, and replenish the earth. **2** The fear of you and the dread of you will be on every animal of the earth, and on every bird of the sky. Everything that moves along the ground, and all the fish of the sea, are delivered into your hand. **3** Every moving thing that lives will be food for you. As I gave you the green herb, I have given everything to you. **4** But flesh with its life, that is, its blood, you shall not eat. **5** I will surely require your blood, the blood of your lives; at the hand of every animal I will require it. At the hand of man, even at the hand of every man's brother, I will require the life of man. **6** Whoever sheds man's blood, his blood will be shed by man, for God made man in his own image. **7** Be fruitful and multiply. Increase abundantly in the earth, and multiply in it."

8 God spoke to Noah and to his sons with him, saying, **9** "As for me, behold, I establish my covenant with you, and with your offspring after you, **10** and with every living creature that is with you: the birds, the livestock, and every animal of the earth with you, of all that go out of the ark, even every animal of the earth. **11** I will establish my covenant with you: All flesh will not be cut off any more by the waters of the flood. There will never again be a flood to destroy the earth." **12** God said, "This is the token of the covenant which I make between me and you and every living creature that is with you, for perpetual generations: **13** I set my rainbow in the cloud, and it will be a sign of a covenant between me and the earth. **14** When I bring a cloud over the earth, that the rainbow will be seen in the cloud, **15** and I will remember my covenant, which is between me and you and every living creature of all flesh, and the waters will no more become a flood to destroy all flesh. **16** The rainbow will be in the cloud. I will look at it, that I may remember the everlasting covenant between God and every living creature of all flesh that is on the earth." **17** God said to Noah, "This is the token of the covenant which I have established between me and all flesh that is on the earth."

18 The sons of Noah who went out from the ark were Shem, Ham, and Japheth. Ham is the father of Canaan. **19** These three were the sons of Noah, and from these, the whole earth was populated.

20 Noah began to be a farmer, and planted a vineyard. **21** He drank of the wine and got drunk. He was uncovered within his tent. **22** Ham, the father of Canaan, saw the nakedness of his father, and told his two brothers outside. **23** Shem and Japheth took a garment, and laid it on both their shoulders, went in backwards, and covered the nakedness of their father. Their faces were backwards, and they didn't see their father's nakedness. **24** Noah awoke from his wine, and knew what his youngest son had done to him. **25** He said,

"Canaan is cursed.
 He will be a servant of servants
 to his brothers."

26 He said,

"Blessed be the LORD, the God of Shem.
 Let Canaan be his servant.

27 May God enlarge Japheth.
 Let him dwell in the tents of Shem.
 Let Canaan be his servant."

28 Noah lived three hundred fifty years after the flood. **29** All the days of Noah were nine hundred fifty years, and then he died.

CHAPTER 10

This is the history of the generations of the sons of Noah and of Shem, Ham, and Japheth. Sons were born to them after the flood.

2 The sons of Japheth were: Gomer, Magog, Madai, Javan, Tubal, Meshech, and Tiras.

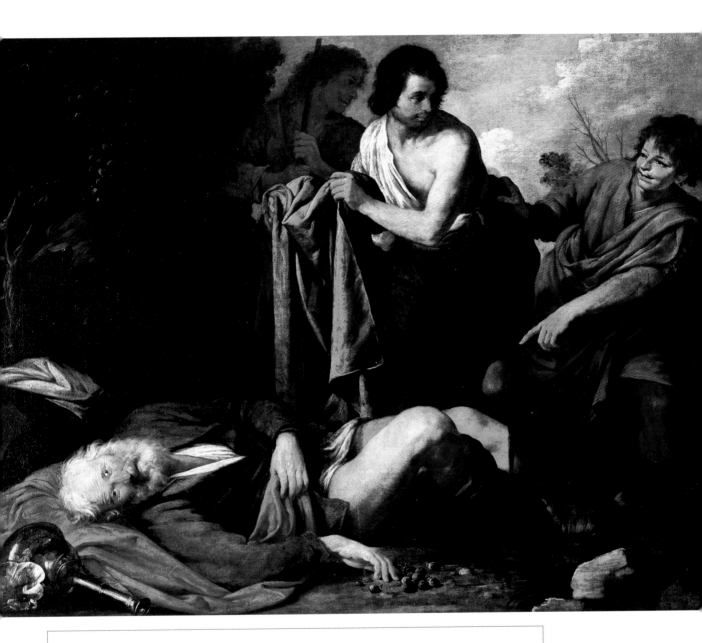

Noah's Drunkenness

Giovanni Andrea de Ferrari

17TH CENTURY

After the flood Noah planted a vineyard, made wine, became drunk, and passed out naked in his tent. Here, a drunken Noah lies on the ground partially exposed. On the right, a smiling Ham points out his father's nakedness to his brothers Shem and Japheth, who try to protect Noah's dignity by covering him while keeping their eyes averted. When Noah awoke and discovered what had happened, he cursed Ham's son Canaan. This story explains the inferior status of the Canaanites, who would later be conquered by Abraham's descendants, the Israelites.

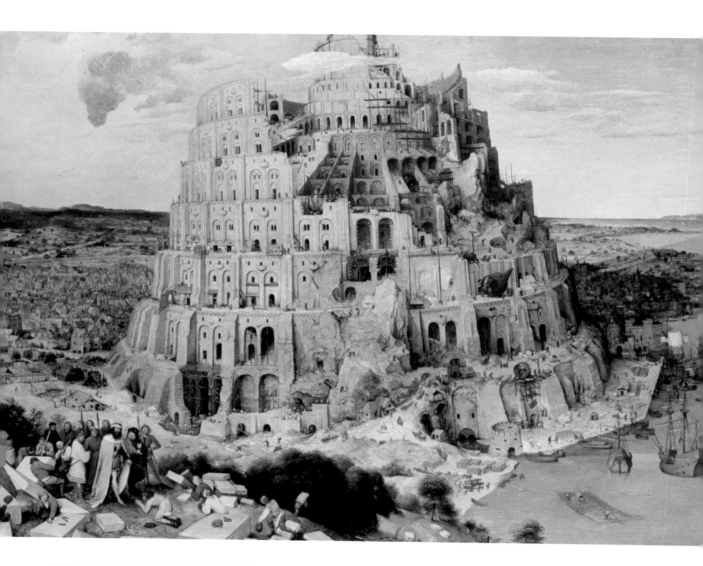

The Tower of Babel

Pieter Bruegel the Elder
1563

The people of the earth, who all spoke a single language, decided to build a monumental tower reaching up to the heavens. Concerned that nothing would be impossible for the human race, God decided to confuse their language so that people would separate and scatter over the earth. The name Babel sounds like the Hebrew word for "confused." The tower is shown under construction in this painting, dwarfing the surrounding town and port. The main figure in the left foreground is probably King Nimrod, who is associated with ordering the tower's construction in non-biblical sources.

3 The sons of Gomer were: Ashkenaz, Riphath, and Togarmah. 4 The sons of Javan were: Elishah, Tarshish, Kittim, and Dodanim. 5 Of these were the islands of the nations divided in their lands, everyone after his language, after their families, in their nations.

6 The sons of Ham were: Cush, Mizraim, Put, and Canaan. 7 The sons of Cush were: Seba, Havilah, Sabtah, Raamah, and Sabteca. The sons of Raamah were: Sheba and Dedan. 8 Cush became the father of Nimrod. He began to be a mighty one in the earth. 9 He was a mighty hunter before the LORD. Therefore it is said, "like Nimrod, a mighty hunter before the LORD". 10 The beginning of his kingdom was Babel, Erech, Accad, and Calneh, in the land of Shinar. 11 Out of that land he went into Assyria, and built Nineveh, Rehoboth Ir, Calah, 12 and Resen between Nineveh and the great city Calah. 13 Mizraim became the father of Ludim, Anamim, Lehabim, Naphtuhim, 14 Pathrusim, Casluhim (which the Philistines descended from), and Caphtorim.

15 Canaan became the father of Sidon (his firstborn), Heth, 16 the Jebusites, the Amorites, the Girgashites, 17 the Hivites, the Arkites, the Sinites, 18 the Arvadites, the Zemarites, and the Hamathites. Afterward the families of the Canaanites were spread abroad. 19 The border of the Canaanites was from Sidon—as you go toward Gerar—to Gaza—as you go toward Sodom, Gomorrah, Admah, and Zeboiim—to Lasha. 20 These are the sons of Ham, after their families, according to their languages, in their lands and their nations.

21 Children were also born to Shem, the father of all the children of Eber, the elder brother of Japheth. 22 The sons of Shem were: Elam, Asshur, Arpachshad, Lud, and Aram. 23 The sons of Aram were: Uz, Hul, Gether, and Mash. 24 Arpachshad became the father of Shelah. Shelah became the father of Eber. 25 To Eber were born two sons. The name of the one was Peleg, for in his days the earth was divided. His brother's name was Joktan. 26 Joktan became the father of Almodad, Sheleph, Hazarmaveth, Jerah, 27 Hadoram, Uzal, Diklah, 28 Obal, Abimael, Sheba, 29 Ophir, Havilah, and Jobab. All these were the sons of Joktan. 30 Their dwelling extended from Mesha, as you go toward Sephar, the mountain of the east. 31 These are the sons of Shem, by their families, according to their languages, lands, and nations.

32 These are the families of the sons of Noah, by their generations, according to their nations. The nations divided from these in the earth after the flood.

CHAPTER 11

The whole earth was of one language and of one speech. 2 As they traveled east, they found a plain in the land of Shinar, and they lived there. 3 They said to one another, "Come, let's make bricks, and burn them thoroughly." They had brick for stone, and they used tar for mortar. 4 They said, "Come, let's build ourselves a city, and a tower whose top reaches to the sky, and let's make a name for ourselves, lest we be scattered abroad on the surface of the whole earth."

5 The LORD came down to see the city and the tower, which the children of men built. 6 The LORD said, "Behold, they are one people, and they have all one language, and this is what they begin to do. Now nothing will be withheld from them, which they intend to do. 7 Come, let's go down, and there confuse their language, that they may not understand one another's speech." 8 So the LORD scattered them abroad from there on the surface of all the earth. They stopped building the city. 9 Therefore its name was called Babel, because there the LORD confused the language of all the earth. From there, the LORD scattered them abroad on the surface of all the earth.

10 This is the history of the generations of Shem: Shem was one hundred years old when he became the father of Arpachshad two years after the flood. 11 Shem lived five hundred years after he became the father of Arpachshad, and became the father of more sons and daughters.

12 Arpachshad lived thirty-five years and became the father of Shelah. 13 Arpachshad lived four hundred three years after he became the father of Shelah, and became the father of more sons and daughters.

14 Shelah lived thirty years, and became the father of Eber. 15 Shelah lived four hundred three years after he became the father of Eber, and became the father of more sons and daughters.

16 Eber lived thirty-four years, and became the father of Peleg. 17 Eber lived four hundred

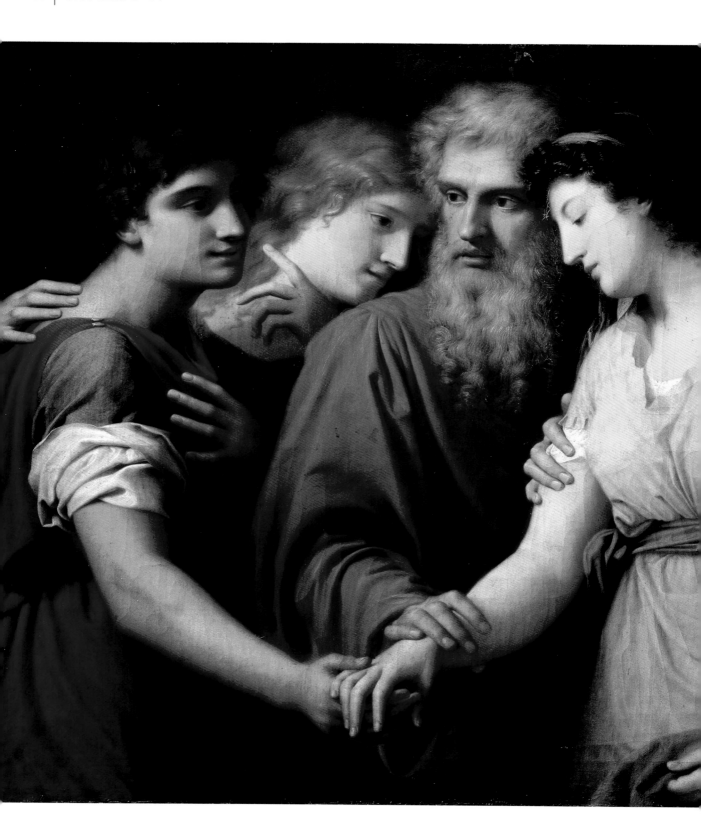

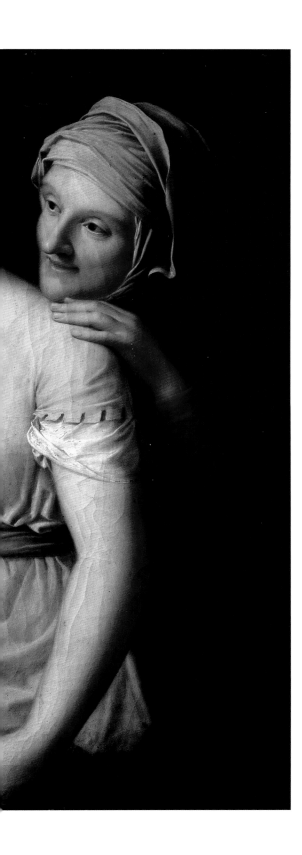

thirty years after he became the father of Peleg, and became the father of more sons and daughters.

¹⁸ Peleg lived thirty years, and became the father of Reu. ¹⁹ Peleg lived two hundred nine years after he became the father of Reu, and became the father of more sons and daughters.

²⁰ Reu lived thirty-two years, and became the father of Serug. ²¹ Reu lived two hundred seven years after he became the father of Serug, and became the father of more sons and daughters.

²² Serug lived thirty years, and became the father of Nahor. ²³ Serug lived two hundred years after he became the father of Nahor, and became the father of more sons and daughters.

²⁴ Nahor lived twenty-nine years, and became the father of Terah. ²⁵ Nahor lived one hundred nineteen years after he became the father of Terah, and became the father of more sons and daughters.

²⁶ Terah lived seventy years, and became the father of Abram, Nahor, and Haran.

²⁷ Now this is the history of the generations of Terah. Terah became the father of Abram, Nahor, and Haran. Haran became the father of Lot. ²⁸ Haran died before his father Terah in the land of his birth, in Ur of the Chaldees. ²⁹ Abram and Nahor married wives. The name of Abram's wife was Sarai, and the name of Nahor's wife was Milcah, the daughter of Haran who was also the father of Iscah. ³⁰ Sarai was barren. She had no child. ³¹ Terah took Abram his son, Lot the son of Haran, his son's son, and Sarai his daughter-in-law, his son Abram's wife. They went from Ur of the Chaldees, to go into the land of Canaan. They came to Haran and lived there. ³² The days of Terah were two hundred five years. Terah died in Haran.

The Marriage of Abraham and Sarah

Gaspare Landi
1791

A young Abram and Sarai—later renamed Abraham and Sarah by God—join hands in marriage. Sarai is noted in the Bible as being extremely beautiful and was Abram's half-sister as well as wife. Abram became the founding father of the Jewish people.

CHAPTERS 12–17

God sends Noah's descendant Abram to the land of Canaan. After a famine there, Abram and his wife Sarai have an adventure in Egypt. Abram and his nephew Lot decide to settle in different areas so that each has enough grazing land. God assures Abram that he will have a child, despite Sarai being barren. Abram takes Sarai's servant Hagar as a second wife and she gives birth to a son, Ishmael. God establishes circumcision as the sign of the covenant between Abram and God, and changes Abram's name to Abraham and Sarai's name to Sarah.

CHAPTER 12

Now the LORD said to Abram, "Leave your country, and your relatives, and your father's house, and go to the land that I will show you. **2** I will make of you a great nation. I will bless you and make your name great. You will be a blessing. **3** I will bless those who bless you, and I will curse him who curses you. All the families of the earth will be blessed through you."

4 So Abram went, as the LORD had told him. Lot went with him. Abram was seventy-five years old when he departed from Haran. **5** Abram took Sarai his wife, Lot his brother's son, all their possessions that they had gathered, and the people whom they had acquired in Haran, and they went to go into the land of Canaan. They entered into the land of Canaan. **6** Abram passed through the land to the place of Shechem, to the oak of Moreh. The Canaanites were in the land, then.

7 The LORD appeared to Abram and said, "I will give this land to your offspring."

He built an altar there to the LORD, who had appeared to him. **8** He left from there to go to the mountain on the east of Bethel and pitched his tent, having Bethel on the west, and Ai on the east. There he built an altar to the LORD and called on the LORD's name. **9** Abram traveled, still going on toward the South.

10 There was a famine in the land. Abram went down into Egypt to live as a foreigner there, for the famine was severe in the land. **11** When he had come near to enter Egypt, he said to Sarai his wife, "See now, I know that you are a beautiful woman to look at. **12** It will happen, when the Egyptians see you, that they will say, 'This is his wife.' They will kill me, but they will save you alive. **13** Please say that you are my sister, that it may be well with me for your sake, and that my soul may live because of you."

14 When Abram had come into Egypt, Egyptians saw that the woman was very beautiful. **15** The princes of Pharaoh saw her, and praised her to Pharaoh; and the woman was taken into Pharaoh's house. **16** He dealt well with Abram for her sake. He had sheep, cattle, male donkeys, male servants, female servants, female donkeys, and camels. **17** The LORD afflicted Pharaoh and his house with great plagues because of Sarai, Abram's wife. **18** Pharaoh called Abram and said, "What is this that you have done to me? Why didn't you tell me that she was your wife? **19** Why did you say, 'She is my sister,' so that I took her to be my wife? Now therefore, see your wife, take her, and go your way."

20 Pharaoh commanded men concerning him, and they escorted him away with his wife and all that he had.

CHAPTER 13

Abram went up out of Egypt—he, his wife, all that he had, and Lot with him—into the South. **2** Abram was very rich in livestock, in silver, and in gold. **3** He went on his journeys from the South even to Bethel, to the place where his tent had been at the beginning, between Bethel and Ai, **4** to the place of the altar, which he had made there at the first. There Abram called on the LORD's name. **5** Lot also, who went with Abram, had flocks, herds, and tents.

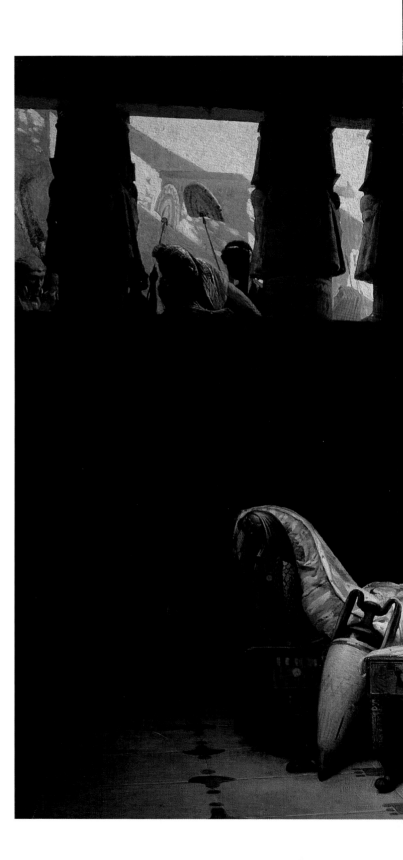

Abraham and Sarah at the Court of Pharaoh

Giovanni Muzzioli
1875

Leaving their home in Canaan because of a famine, Abram and his wife Sarai traveled to Egypt. Afraid that the Egyptians would kill him in order to take his beautiful wife, Abram told Sarai to pretend that she was just his sister. Pleased with Sarai's beauty and unaware that she was already married, Pharaoh took Sarai into his household and gave Abram gifts in exchange. This painting shows Abram and Sarai consorting secretly outside Pharaoh's palace.

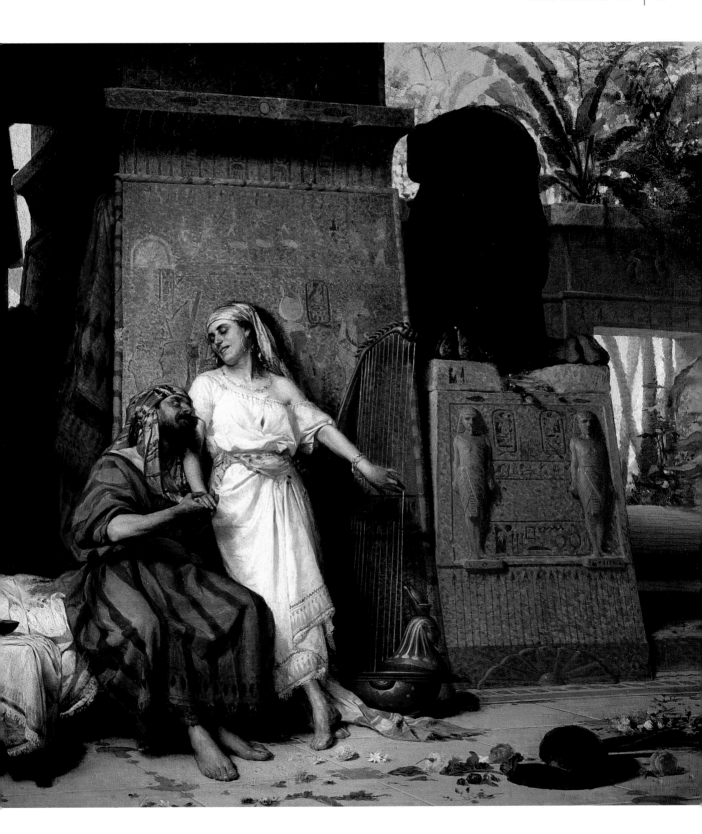

So Lot chose the plain of the Jordan for himself. Lot traveled east, and they separated themselves the one from the other. Abram lived in the land of Canaan, and Lot lived in the cities of the plain, and moved his tent as far as Sodom. Now the men of Sodom were exceedingly wicked and sinners against the LORD.

Genesis 13:11–13

6 The land was not able to bear them, that they might live together; for their substance was great, so that they could not live together. **7** There was strife between the herdsmen of Abram's livestock and the herdsmen of Lot's livestock. The Canaanites and the Perizzites lived in the land at that time. **8** Abram said to Lot, "Please, let there be no strife between you and me, and between your herdsmen and my herdsmen; for we are relatives. **9** Isn't the whole land before you? Please separate yourself from me. If you go to the left hand, then I will go to the right. Or if you go to the right hand, then I will go to the left."

10 Lot lifted up his eyes, and saw all the plain of the Jordan, that it was well-watered everywhere, before the LORD destroyed Sodom and Gomorrah, like the garden of the LORD, like the land of Egypt, as you go to Zoar. **11** So Lot chose the plain of the Jordan for himself. Lot traveled east, and they separated themselves the one from the other. **12** Abram lived in the land of Canaan, and Lot lived in the cities of the plain, and moved his tent as far as Sodom. **13** Now the men of Sodom were exceedingly wicked and sinners against the LORD.

14 The LORD said to Abram, after Lot was separated from him, "Now, lift up your eyes, and look from the place where you are, northward and southward and eastward and westward, **15** for all the land which you see, I will give to you, and to your offspring forever. **16** I will make your offspring as the dust of the earth, so that if a man can count the dust of the earth, then your offspring may also be counted. **17** Arise, walk through the land in its length and in its width; for I will give it to you."

18 Abram moved his tent, and came and lived by the oaks of Mamre, which are in Hebron, and built an altar there to the LORD.

CHAPTER 14

In the days of Amraphel, king of Shinar, Arioch, king of Ellasar, Chedorlaomer, king of Elam, and Tidal, king of Goiim, **2** they made war with Bera, king of Sodom, and with Birsha, king of Gomorrah, Shinab, king of Admah, and Shemeber, king of Zeboiim, and the king of Bela (also called Zoar). **3** All these joined together in the valley of Siddim (also called the Salt Sea). **4** They served Chedorlaomer for twelve years, and in the thirteenth year, they rebelled. **5** In the fourteenth year Chedorlaomer came, and the kings who were with him, and struck the Rephaim in Ashteroth Karnaim, and the Zuzim in Ham, and the Emim in Shaveh Kiriathaim, **6** and the Horites in their Mount Seir, to El Paran, which is by the wilderness. **7** They returned, and came to En Mishpat (also called Kadesh), and struck all the

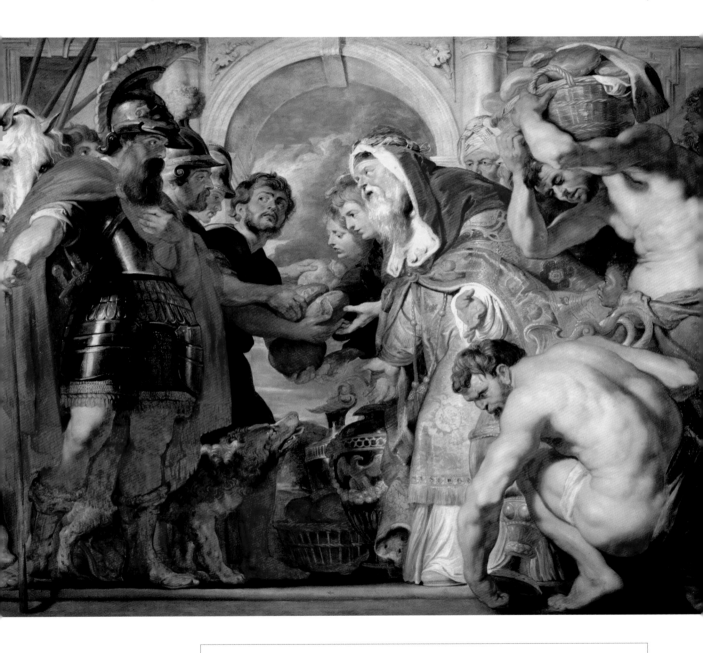

Abraham and Melchizedek

Peter Paul Rubens
1615–18

Abram gathered an army and attacked the Mesopotamian conquerors of the city of Sodom in order to rescue his nephew, Lot. Melchizedek, a priest-king of Salem (traditionally identified as Jerusalem), received the victorious Abram on his return with bread, wine, and a blessing. Abram stands at the front left of this painting in military attire, while the white-bearded Melchizedek faces him wearing priestly robes.

Abram said, "Lord God, what will you give me, since I go childless, and he who will inherit my estate is Eliezer of Damascus?"...Behold, the LORD's word came to him, saying, "This man will not be your heir, but he who will come out of your own body will be your heir." The LORD brought him outside, and said, "Look now toward the sky, and count the stars, if you are able to count them." He said to Abram, "So will your offspring be."

Genesis 15:2–5

country of the Amalekites, and also the Amorites, that lived in Hazazon Tamar. **8** The king of Sodom, and the king of Gomorrah, and the king of Admah, and the king of Zeboiim, and the king of Bela (also called Zoar) went out; and they set the battle in array against them in the valley of Siddim; **9** against Chedorlaomer king of Elam, and Tidal king of Goiim, and Amraphel king of Shinar, and Arioch king of Ellasar; four kings against the five. **10** Now the valley of Siddim was full of tar pits; and the kings of Sodom and Gomorrah fled, and some fell there, and those who remained fled to the hills. **11** They took all the goods of Sodom and Gomorrah, and all their food, and went their way. **12** They took Lot, Abram's brother's son, who lived in Sodom, and his goods, and departed.

13 One who had escaped came and told Abram, the Hebrew. At that time, he lived by the oaks of Mamre, the Amorite, brother of Eshcol, and brother of Aner; and they were allies of Abram. **14** When Abram heard that his relative was taken captive, he led out his trained men, born in his house, three hundred and eighteen, and pursued as far as Dan. **15** He divided himself against them by night, he and his servants, and struck them, and pursued them to Hobah, which is on the left hand of Damascus. **16** He brought back all the goods, and also brought back his relative, Lot, and his goods, and the women also, and the other people.

17 The king of Sodom went out to meet him after his return from the slaughter of Chedorlaomer and the kings who were with him, at the valley of Shaveh (that is, the King's Valley). **18** Melchizedek king of Salem brought out bread and wine: and he was priest of God Most High. **19** He blessed him, and said, "Blessed be Abram of God Most High, possessor of heaven and earth: **20** and blessed be God Most High, who has delivered your enemies into your hand."

Abram gave him a tenth of all.

21 The king of Sodom said to Abram, "Give me the people, and take the goods for yourself."

22 Abram said to the king of Sodom, "I have lifted up my hand to the LORD, God Most High, possessor of heaven and earth, **23** that I will not take a thread nor a sandal strap nor anything that is yours, lest you

should say, 'I have made Abram rich.' **24** I will accept nothing from you except that which the young men have eaten, and the portion of the men who went with me: Aner, Eshcol, and Mamre. Let them take their portion."

CHAPTER 15

After these things the LORD's word came to Abram in a vision, saying, "Don't be afraid, Abram. I am your shield, your exceedingly great reward."

2 Abram said, "Lord God, what will you give me, since I go childless, and he who will inherit my estate is Eliezer of Damascus?" **3** Abram said, "Behold, to me you have given no children: and, behold, one born in my house is my heir."

4 Behold, the LORD's word came to him, saying, "This man will not be your heir, but he who will come out of your own body will be your heir." **5** The LORD brought him outside, and said, "Look now toward the sky, and count the stars, if you are able to count them." He said to Abram, "So will your offspring be." **6** He believed in the LORD, who credited it to him for righteousness. **7** He said to Abram, "I am the LORD who brought you out of Ur of the Chaldees, to give you this land to inherit it."

8 He said, "Lord God, how will I know that I will inherit it?"

9 He said to him, "Bring me a heifer three years old, a female goat three years old, a ram three years old, a turtledove, and a young pigeon." **10** He brought him all these, and divided them in the middle, and laid each half opposite the other; but he didn't divide the birds. **11** The birds of prey came down on the carcasses, and Abram drove them away.

12 When the sun was going down, a deep sleep fell on Abram. Now terror and great darkness fell on him. **13** He said to Abram, "Know for sure that your offspring will live as foreigners in a land that is not theirs, and will serve them. They will afflict them four hundred years. **14** I will also judge that nation, whom they will serve. Afterward they will come out with great wealth, **15** but you will go to your fathers in peace. You will be buried at a good old age. **16** In the fourth

generation they will come here again, for the iniquity of the Amorite is not yet full." **17** It came to pass that, when the sun went down, and it was dark, behold, a smoking furnace, and a flaming torch passed between these pieces. **18** In that day the LORD made a covenant with Abram, saying, "I have given this land to your offspring, from the river of Egypt to the great river, the river Euphrates: **19** the Kenites, the Kenizzites, the Kadmonites, **20** the Hittites, the Perizzites, the Rephaim, **21** the Amorites, the Canaanites, the Girgashites, and the Jebusites."

CHAPTER 16

Now Sarai, Abram's wife, bore him no children. She had a servant, an Egyptian, whose name was Hagar. **2** Sarai said to Abram, "See now, the LORD has restrained me from bearing. Please go in to my servant. It may be that I will obtain children by her." Abram listened to the voice of Sarai. **3** Sarai, Abram's wife, took Hagar the Egyptian, her servant, after Abram had lived ten years in the land of Canaan, and gave her to Abram her husband to be his wife. **4** He went in to Hagar, and she conceived. When she saw that she had conceived, her mistress was despised in her eyes. **5** Sarai said to Abram, "This wrong is your fault. I gave my servant into your bosom, and when she saw that she had conceived, I was despised in her eyes. The LORD judge between me and you."

6 But Abram said to Sarai, "Behold, your maid is in your hand. Do to her whatever is good in your eyes." Sarai dealt harshly with her, and she fled from her presence.

7 The LORD's angel found her by a fountain of water in the wilderness, by the fountain on the way to Shur. **8** He said, "Hagar, Sarai's servant, where did you come from? Where are you going?"

She said, "I am fleeing from the presence of my mistress Sarai."

9 The LORD's angel said to her, "Return to your mistress, and submit yourself under her hands." **10** The LORD's angel said to her, "I will greatly multiply your offspring, that they will not be counted for multitude." **11** The LORD's angel said to her, "Behold, you are with child,

Hagar Leaves the House of Abraham

Peter Paul Rubens
c. 1615–17

Abram's wife, Sarai, offered her servant Hagar to her husband as a concubine because she herself had been unable to bear children. When Hagar became pregnant and looked contemptuously on her mistress, Abram told his wife to do with Hagar as she pleased. Here, an angry Sarai drives the pregnant Hagar from the house, while Abram stands watching from the doorway.

and will bear a son. You shall call his name Ishmael, because the LORD has heard your affliction. **12** He will be like a wild donkey among men. His hand will be against every man, and every man's hand against him. He will live opposite all of his brothers."

13 She called the name of the LORD who spoke to her, "You are a God who sees"; for she said, "Have I even stayed alive after seeing him?" **14** Therefore the well was called Beer Lahai Roi [*"well of the one who lives and sees me"*]. Behold, it is between Kadesh and Bered.

15 Hagar bore a son for Abram. Abram called the name of his son, whom Hagar bore, Ishmael. **16** Abram was eighty-six years old when Hagar bore Ishmael to Abram.

CHAPTER 17

When Abram was ninety-nine years old, the LORD appeared to Abram and said to him, "I am God Almighty. Walk before me, and be blameless. **2** I will make my covenant between me and you, and will multiply you exceedingly."

3 Abram fell on his face. God talked with him, saying, **4** "As for me, behold, my covenant is with you. You will be the father of a multitude of nations. **5** Your name will no more be called Abram, but your name will be Abraham; for I have made you the father of a multitude of nations. **6** I will make you exceedingly fruitful, and I will make nations of you. Kings will come out of you. **7** I will establish my covenant between me and you and your offspring after you throughout their generations for an everlasting covenant, to be a God to you and to your offspring after you. **8** I will give to you, and to your offspring after you, the land where you are traveling, all the land of Canaan, for an everlasting possession. I will be their God."

9 God said to Abraham, "As for you, you will keep my covenant, you and your offspring after you throughout their generations. **10** This is my covenant, which you shall keep, between me and you and your offspring after you. Every male among you shall be circumcised. **11** You shall be circumcised in the flesh of your foreskin. It will be a token of the covenant between me and you. **12** He who is

eight days old will be circumcised among you, every male throughout your generations, he who is born in the house, or bought with money from any foreigner who is not of your offspring. **13** He who is born in your house, and he who is bought with your money, must be circumcised. My covenant will be in your flesh for an everlasting covenant. **14** The uncircumcised male who is not circumcised in the flesh of his foreskin, that soul shall be cut off from his people. He has broken my covenant."

15 God said to Abraham, "As for Sarai your wife, you shall not call her name Sarai, but her name will be Sarah. **16** I will bless her, and moreover I will give you a son by her. Yes, I will bless her, and she will be a mother of nations. Kings of peoples will come from her."

17 Then Abraham fell on his face, and laughed, and said in his heart, "Will a child be born to him who is one hundred years old? Will Sarah, who is ninety years old, give birth?" **18** Abraham said to God, "Oh that Ishmael might live before you!"

19 God said, "No, but Sarah, your wife, will bear you a son. You shall call his name Isaac. I will establish my covenant with him for an everlasting covenant for his offspring after him. **20** As for Ishmael, I have heard you. Behold, I have blessed him, and will make him fruitful, and will multiply him exceedingly. He will become the father of twelve princes, and I will make him a great nation. **21** But my covenant I establish with Isaac, whom Sarah will bear to you at this set time next year."

22 When he finished talking with him, God went up from Abraham. **23** Abraham took Ishmael his son, all who were born in his house, and all who were bought with his money; every male among the men of Abraham's house, and circumcised the flesh of their foreskin in the same day, as God had said to him. **24** Abraham was ninety-nine years old, when he was circumcised in the flesh of his foreskin. **25** Ishmael, his son, was thirteen years old when he was circumcised in the flesh of his foreskin. **26** In the same day both Abraham and Ishmael, his son, were circumcised. **27** All the men of his house, those born in the house, and those bought with money from a foreigner, were circumcised with him.

CHAPTERS 18—19

Three visitors—God and two angels in the form of men—arrive at Abraham's home and he offers them hospitality. God reveals his intention to destroy Sodom, where Abraham's nephew Lot and his family live, for its wickedness. Lot and two of his daughters leave Sodom before it is destroyed, but his wife perishes—she does not heed God's warning not to look back or linger, and turns into a pillar of salt when she does so. Then Lot's two daughters get their father drunk so that he will impregnate them.

CHAPTER 18

The Lord appeared to him by the oaks of Mamre, as he sat in the tent door in the heat of the day. **2** He lifted up his eyes and looked, and saw that three men stood opposite him. When he saw them, he ran to meet them from the tent door, and bowed himself to the earth, **3** and said, "My lord, if now I have found favor in your sight, please don't go away from your servant. **4** Now let a little water be fetched, wash your feet, and rest yourselves under the tree. **5** I will get a morsel of bread so you can refresh your heart. After that you may go your way, now that you have come to your servant."

They said, "Very well, do as you have said."

6 Abraham hurried into the tent to Sarah, and said, "Quickly prepare three measures of fine meal, knead it, and make cakes." **7** Abraham ran to the herd, and fetched a tender and good calf, and gave it to the servant. He hurried to dress it. **8** He took butter, milk, and the calf which he had dressed, and set it before them. He stood by them under the tree, and they ate.

9 They asked him, "Where is Sarah, your wife?"

He said, "See, in the tent."

10 He said, "I will certainly return to you at about this time next year; and behold, Sarah your wife will have a son."

Sarah heard in the tent door, which was behind him. **11** Now Abraham and Sarah were old, well advanced in age. Sarah had passed the age of childbearing. **12** Sarah laughed within herself, saying, "After I have grown old will I have pleasure, my lord being old also?"

13 The Lord said to Abraham, "Why did Sarah laugh, saying, 'Will I really bear a child, yet I am old?' **14** Is anything too hard for the Lord? At the set time I will return to you, when the season comes round, and Sarah will have a son."

15 Then Sarah denied it, saying, "I didn't laugh," for she was afraid.

He said, "No, but you did laugh."

16 The men rose up from there, and looked toward Sodom. Abraham went with them to see them on their way. **17** The Lord said, "Will I hide from Abraham what I do, **18** since Abraham will surely become a great and mighty nation, and all the nations of the earth will be blessed in him? **19** For I have known him, to the end that he may command his children and his household after him, that they may keep the way of the Lord, to do righteousness and justice; to the end that the Lord may bring on Abraham that which he has spoken of him." **20** The Lord said, "Because the cry of Sodom and Gomorrah is great, and because their sin is very grievous, **21** I will go down now, and see whether their deeds are as bad as the reports which have come to me. If not, I will know."

22 The men turned from there, and went toward Sodom, but Abraham stood yet before the Lord. **23** Abraham came near, and said, "Will you consume the righteous with the wicked? **24** What if there are fifty righteous within the city? Will you consume and not spare the place for the fifty righteous who are in it? **25** Be it far from you to do things like that, to kill the righteous with the wicked, so that the righteous should be like the wicked. May that be far from you. Shouldn't the Judge of all the earth do right?"

26 The Lord said, "If I find in Sodom fifty righteous within the city, then I will spare the whole place for their sake." **27** Abraham

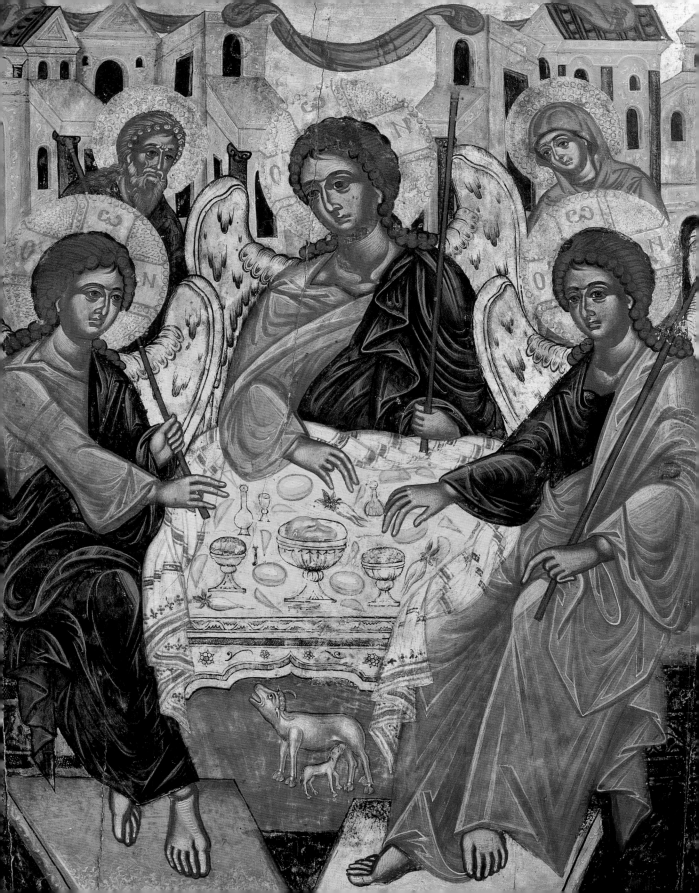

answered, "See now, I have taken it on myself to speak to the Lord, although I am dust and ashes. **28** What if there will lack five of the fifty righteous? Will you destroy all the city for lack of five?"

He said, "I will not destroy it if I find forty-five there."

29 He spoke to him yet again, and said, "What if there are forty found there?"

He said, "I will not do it for the forty's sake."

30 He said, "Oh don't let the Lord be angry, and I will speak. What if there are thirty found there?"

He said, "I will not do it if I find thirty there."

31 He said, "See now, I have taken it on myself to speak to the Lord. What if there are twenty found there?"

He said, "I will not destroy it for the twenty's sake."

32 He said, "Oh don't let the Lord be angry, and I will speak just once more. What if ten are found there?"

He said, "I will not destroy it for the ten's sake."

33 The LORD went his way, as soon as he had finished communing with Abraham, and Abraham returned to his place.

The Hospitality of Abraham and Sarah to the Three Angels

Greek School

17TH CENTURY

This Greek icon shows Abraham and his wife Sarah, standing behind the seated figures, offering hospitality to their angelic visitors. The biblical text is ambiguous about the identity of the visitors. They are usually identified as God and two angels, but sometimes as three angels, with God being a separate presence at this event. It was during this meal that God revealed that Sarah would soon have a son, despite being past childbearing age.

CHAPTER 19

The two angels came to Sodom at evening. Lot sat in the gate of Sodom. Lot saw them, and rose up to meet them. He bowed himself with his face to the earth, **2** and he said, "See now, my lords, please turn aside into your servant's house, stay all night, wash your feet, and you can rise up early, and go on your way."

They said, "No, but we will stay in the street all night."

3 He urged them greatly, and they came in with him, and entered into his house. He made them a feast, and baked unleavened bread, and they ate. **4** But before they lay down, the men of the city, the men of Sodom, surrounded the house, both young and old, all the people from every quarter. **5** They called to Lot, and said to him, "Where are the men who came in to you this night? Bring them out to us, that we may have sex with them."

6 Lot went out to them to the door, and shut the door after him. **7** He said, "Please, my brothers, don't act so wickedly. **8** See now, I have two virgin daughters. Please let me bring them out to you, and you may do to them what seems good to you. Only don't do anything to these men, because they have come under the shadow of my roof."

9 They said, "Stand back!" Then they said, "This one fellow came in to live as a foreigner, and he appoints himself a judge. Now will we deal worse with you, than with them!" They pressed hard on the man Lot, and came near to break the door. **10** But the men reached out their hand, and brought Lot into the house to them, and shut the door. **11** They struck the men who were at the door of the house with blindness, both small and great, so that they wearied themselves to find the door.

12 The men said to Lot, "Do you have anybody else here? Sons-in-law, your sons, your daughters, and whoever you have in the city, bring them out of the place: **13** for we will destroy this place, because the outcry against them has grown so great before the LORD that the LORD has sent us to destroy it."

14 Lot went out, and spoke to his sons-in-law, who were pledged to marry his daughters, and said, "Get up! Get out of this place, for the LORD will destroy the city."

But he seemed to his sons-in-law to be joking. **15** When the morning came, then

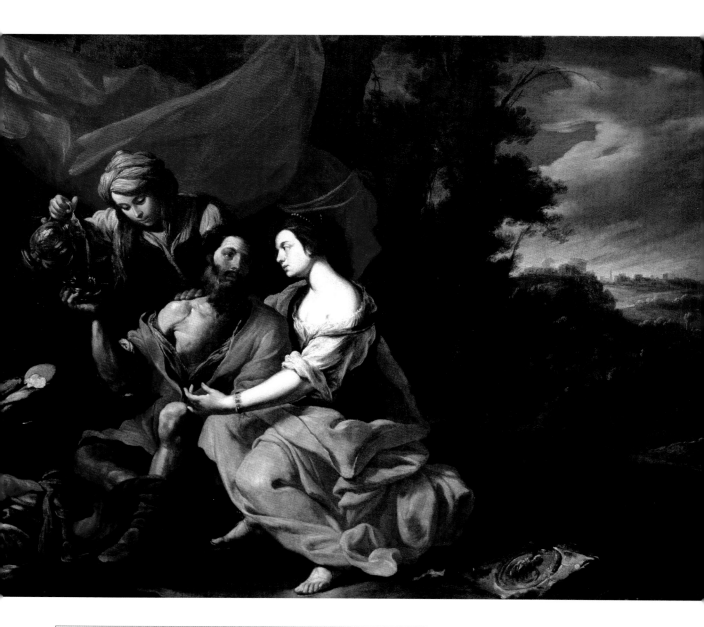

Lot and His Daughters

Agostino Beltrano
17TH CENTURY

Lot and his two daughters escaped God's destruction of the city
of Sodom and ended up living in a cave, far from any other people.
Fearful of never having children, the daughters gave their father wine
and slept with him. One daughter gave birth to a son named Moab
and the other to a son named Ammon. A descendant of Moab, Ruth,
became the great-grandmother of David, king of Israel.

The firstborn said to the younger, "Our father is old, and there is not a man in the earth to come in to us in the way of all the earth. Come, let's make our father drink wine, and we will lie with him, that we may preserve our father's family line."

Genesis 19:31—32

the angels hurried Lot, saying, "Get up! Take your wife, and your two daughters who are here, lest you be consumed in the iniquity of the city." **16** But he lingered; and the men grabbed his hand, his wife's hand, and his two daughters' hands, the LORD being merciful to him; and they took him out, and set him outside of the city. **17** It came to pass, when they had taken them out, that he said, "Escape for your life! Don't look behind you, and don't stay anywhere in the plain. Escape to the mountains, lest you be consumed!"

18 Lot said to them, "Oh, not so, my lord. **19** See now, your servant has found favor in your sight, and you have magnified your loving kindness, which you have shown to me in saving my life. I can't escape to the mountain, lest evil overtake me, and I die. **20** See now, this city is near to flee to, and it is a little one. Oh let me escape there (isn't it a little one?), and my soul will live."

21 He said to him, "Behold, I have granted your request concerning this thing also, that I will not overthrow the city of which you have spoken. **22** Hurry, escape there, for I can't do anything until you get there." Therefore the name of the city was called Zoar [*"little"*].

23 The sun had risen on the earth when Lot came to Zoar. **24** Then the LORD rained on Sodom and on Gomorrah sulfur and fire from the LORD out of the sky. **25** He overthrew those cities, all the plain, all the inhabitants of the cities, and that which grew on the ground. **26** But his wife looked back from behind him, and she became a pillar of salt.

27 Abraham got up early in the morning to the place where he had stood before the LORD.

28 He looked toward Sodom and Gomorrah, and toward all the land of the plain, and looked, and saw that the smoke of the land went up as the smoke of a furnace.

29 When God destroyed the cities of the plain, God remembered Abraham, and sent Lot out of the middle of the overthrow, when he overthrew the cities in which Lot lived.

30 Lot went up out of Zoar, and lived in the mountain, and his two daughters with him; for he was afraid to live in Zoar. He lived in a cave with his two daughters. **31** The firstborn said to the younger, "Our father is old, and there is not a man in the earth to come in to us in the way of all the earth. **32** Come, let's make our father drink wine, and we will lie with him, that we may preserve our father's family line." **33** They made their father drink wine that night: and the firstborn went in, and lay with her father. He didn't know when she lay down, nor when she arose. **34** It came to pass on the next day, that the firstborn said to the younger, "Behold, I lay last night with my father. Let us make him drink wine again, tonight. You go in, and lie with him, that we may preserve our father's family line." **35** They made their father drink wine that night also. The younger went and lay with him. He didn't know when she lay down, nor when she got up. **36** Thus both of Lot's daughters were with child by their father. **37** The firstborn bore a son, and named him Moab. He is the father of the Moabites to this day. **38** The younger also bore a son, and called his name Ben Ammi. He is the father of the children of Ammon to this day.

CHAPTERS 20—23

Abraham lies to King Abimelek about the fact that Sarah is his wife, but God reveals the truth in a dream, so Abimelek sends them away. Sarah finally gives birth to a son, Isaac. She then forces Abraham to send Hagar and her son Ishmael into exile so that Isaac can become heir. Meanwhile, Abraham makes a peace treaty with Abimelek. God tests Abraham by ordering him to sacrifice Isaac, but at the very last minute, God stops Abraham from doing so. Sarah dies at the age of 127 and Abraham buries her in a cave in Hebron.

CHAPTER 20

Abraham traveled from there toward the land of the South, and lived between Kadesh and Shur. He lived as a foreigner in Gerar. **2** Abraham said about Sarah his wife, "She is my sister." Abimelech king of Gerar sent, and took Sarah. **3** But God came to Abimelech in a dream of the night, and said to him, "Behold, you are a dead man, because of the woman whom you have taken. For she is a man's wife."

4 Now Abimelech had not come near her. He said, "Lord, will you kill even a righteous nation? **5** Didn't he tell me, 'She is my sister?' She, even she herself, said, 'He is my brother.' In the integrity of my heart and the innocence of my hands have I done this."

6 God said to him in the dream, "Yes, I know that in the integrity of your heart you have done this, and I also withheld you from sinning against me. Therefore I didn't allow you to touch her. **7** Now therefore, restore the man's wife. For he is a prophet, and he will pray for you, and you will live. If you don't restore her, know for sure that you will die, you, and all who are yours."

8 Abimelech rose early in the morning, and called all his servants, and told all these things in their ear. The men were very scared. **9** Then Abimelech called Abraham, and said to him, "What have you done to us? How have I sinned against you, that you have brought on me and on my kingdom a great sin? You have done deeds to me that ought not to be done!" **10** Abimelech said to Abraham, "What did you see, that you have done this thing?"

11 Abraham said, "Because I thought, 'Surely the fear of God is not in this place. They will kill me for my wife's sake.' **12** Besides, she is indeed my sister, the daughter of my father, but not the daughter of my mother; and she became my wife. **13** When God caused me to wander from my father's house, I said to her, 'This is your kindness which you shall show to me. Everywhere that we go, say of me, "He is my brother."'"

14 Abimelech took sheep and cattle, male servants and female servants, and gave them to Abraham, and restored Sarah, his wife, to him. **15** Abimelech said, "Behold, my land is before you. Dwell where it pleases you." **16** To Sarah he said, "Behold, I have given your brother a thousand pieces of silver. Behold, it is for you a covering of the eyes to all that are with you. In front of all you are vindicated."

17 Abraham prayed to God. God healed Abimelech, and his wife, and his female servants, and they bore children. **18** For the LORD had closed up tight all the wombs of the house of Abimelech, because of Sarah, Abraham's wife.

CHAPTER 21

The LORD visited Sarah as he had said, and the LORD did to Sarah as he had spoken. **2** Sarah conceived, and bore Abraham a son in his old age, at the set time of which God had spoken to him. **3** Abraham called his son who was born to him, whom Sarah bore to him, Isaac. **4** Abraham circumcised his son, Isaac, when he was eight days old, as God had commanded him. **5** Abraham was one hundred years old when his son, Isaac, was born to him. **6** Sarah said, "God has made me laugh. Everyone who hears will laugh with me" [*Isaac means "he laughs"*]. **7** She said, "Who would have said to Abraham, that Sarah would nurse children? For I have borne him a son in his old age."

8 The child grew, and was weaned. Abraham made a great feast on the day that Isaac was weaned. **9** Sarah saw the son of Hagar the Egyptian, whom she had borne to Abraham, mocking. **10** Therefore she said to Abraham, "Cast out this servant and her son! For the son of this servant will not be heir with my son, Isaac."

11 The thing was very grievous in Abraham's sight on account of his son. **12** God said to Abraham, "Don't let it be grievous in your sight because of the boy, and because of your servant. In all that Sarah says to you, listen to her voice. For your offspring will be accounted as from Isaac. **13** I will also make a nation of the son of the servant, because he is your child." **14** Abraham rose up early in the morning, and took bread and a bottle of water, and gave it to Hagar, putting it on her shoulder; and gave her the child, and sent her away. She departed, and wandered in the wilderness of Beersheba. **15** The water in the bottle was spent, and she cast the child under one of the shrubs. **16** She went and sat down opposite him, a good way off, about a bow shot away. For she said, "Don't let me see the death of the child." She sat over against him, and lifted up her voice, and wept. **17** God heard the voice of the boy.

The angel of God called to Hagar out of the sky, and said to her, "What ails you, Hagar? Don't be afraid. For God has heard the voice of the boy where he is. **18** Get up, lift up the boy, and hold him in your hand. For I will make him a great nation."

19 God opened her eyes, and she saw a well of water. She went, filled the bottle with water, and gave the boy drink. **20** God was with the boy, and he grew. He lived in the

Hagar and the Angel

Girolamo da Treviso the Younger
16TH CENTURY

After his first wife Sarah gave birth to their son Isaac, Abraham drove his secondary wife Hagar and their son Ishmael into exile. When they ran out of water, God heard Ishmael's voice and sent an angel to show Hagar a well of water.

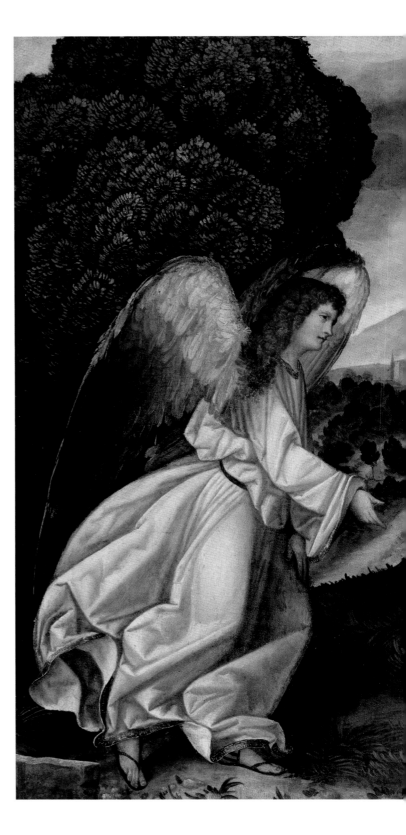

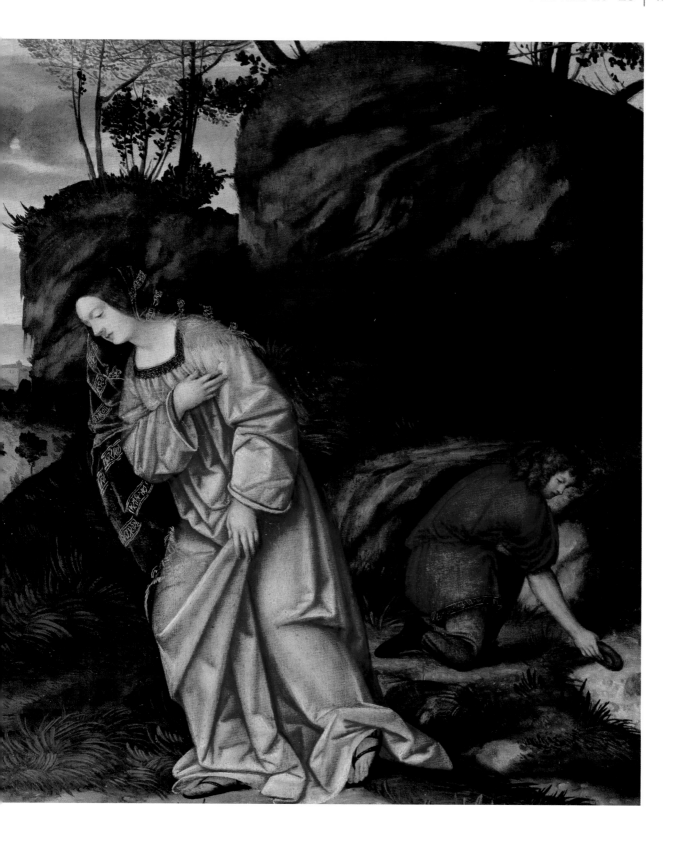

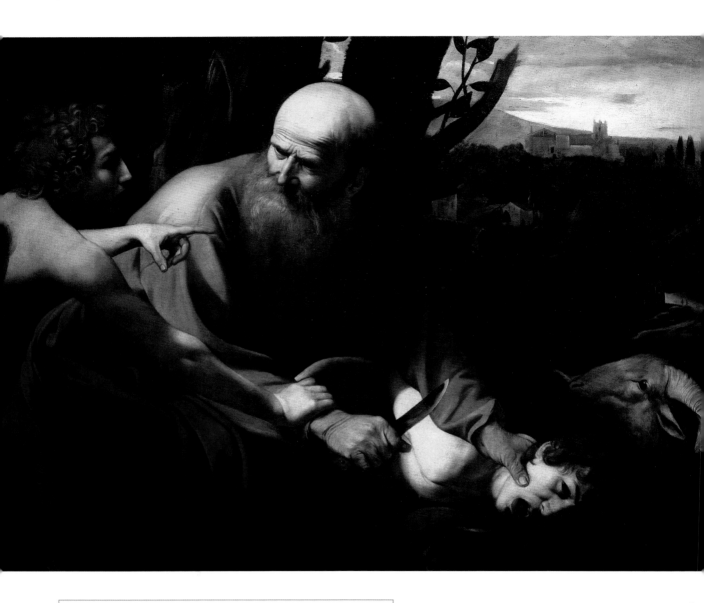

The Sacrifice of Isaac

Michelangelo Merisi da Caravaggio
1603–04

This dramatic painting depicts the startling story of the ultimate test of Abraham's faith. God instructed Abraham to sacrifice his son Isaac as a burnt offering, but at the very last minute God stopped Abraham because his willingness to make the sacrifice had proven his fear of God. Here, Abraham holds down the terrified Isaac, on the verge of killing his son with the knife, when an angel of God stays Abraham's hand and points to a ram. Abraham sacrificed the ram in Isaac's place.

wilderness, and became, as he grew up, an archer. **21** He lived in the wilderness of Paran. His mother took a wife for him out of the land of Egypt.

22 At that time, Abimelech and Phicol the captain of his army spoke to Abraham, saying, "God is with you in all that you do. **23** Now, therefore, swear to me here by God that you will not deal falsely with me, nor with my son, nor with my son's son. But according to the kindness that I have done to you, you shall do to me, and to the land in which you have lived as a foreigner."

24 Abraham said, "I will swear." **25** Abraham complained to Abimelech because of a water well, which Abimelech's servants had violently taken away. **26** Abimelech said, "I don't know who has done this thing. You didn't tell me, and I didn't hear of it until today."

27 Abraham took sheep and cattle, and gave them to Abimelech. Those two made a covenant. **28** Abraham set seven ewe lambs of the flock by themselves. **29** Abimelech said to Abraham, "What do these seven ewe lambs which you have set by themselves mean?"

30 He said, "You shall take these seven ewe lambs from my hand, that it may be a witness to me, that I have dug this well." **31** Therefore he called that place Beersheba, because they both swore there. **32** So they made a covenant at Beersheba [*Beersheba means "well of the oath" or "well of seven"*]. Abimelech rose up with Phicol, the captain of his army, and they returned into the land of the Philistines. **33** Abraham planted a tamarisk tree in Beersheba, and called there on the name of the LORD, the Everlasting God. **34** Abraham lived as a foreigner in the land of the Philistines many days.

CHAPTER 22

After these things, God tested Abraham, and said to him, "Abraham!"

He said, "Here I am."

2 He said, "Now take your son, your only son, whom you love, even Isaac, and go into the land of Moriah. Offer him there as a burnt offering on one of the mountains which I will tell you of."

3 Abraham rose early in the morning, and saddled his donkey, and took two of his young men with him, and Isaac his son. He split the wood for the burnt offering, and rose up, and went to the place of which God had told him. **4** On the third day Abraham lifted up his eyes, and saw the place far off. **5** Abraham said to his young men, "Stay here with the donkey. The boy and I will go yonder. We will worship, and come back to you." **6** Abraham took the wood of the burnt offering and laid it on Isaac his son. He took in his hand the fire and the knife. They both went together. **7** Isaac spoke to Abraham his father, and said, "My father?"

He said, "Here I am, my son."

He said, "Here is the fire and the wood, but where is the lamb for a burnt offering?"

8 Abraham said, "God will provide himself the lamb for a burnt offering, my son." So they both went together. **9** They came to the place which God had told him of. Abraham built the altar there, and laid the wood in order, bound Isaac his son, and laid him on the altar, on the wood. **10** Abraham stretched out his hand, and took the knife to kill his son.

11 The LORD's angel called to him out of the sky, and said, "Abraham, Abraham!"

He said, "Here I am."

12 He said, "Don't lay your hand on the boy or do anything to him. For now I know that you fear God, since you have not withheld your son, your only son, from me."

13 Abraham lifted up his eyes, and looked, and saw that behind him was a ram caught in the thicket by his horns. Abraham went and took the ram, and offered him up for a burnt offering instead of his son. **14** Abraham called the name of that place The LORD Will Provide. As it is said to this day, "On the LORD's mountain, it will be provided."

15 The LORD's angel called to Abraham a second time out of the sky, **16** and said, "I have sworn by myself, says the LORD, because you have done this thing, and have not withheld your son, your only son, **17** that I will bless you greatly, and I will multiply your offspring greatly like the stars of the heavens, and like the sand which is on the seashore. Your offspring will possess the gate of his enemies. **18** All the nations of the earth will be blessed by your offspring, because you have obeyed my voice."

19 So Abraham returned to his young men, and they rose up and went together to Beersheba. Abraham lived at Beersheba.

20 After these things, Abraham was told, "Behold, Milcah, she also has borne children to your brother Nahor: **21** Uz his firstborn, Buz his brother, Kemuel the father of Aram, **22** Chesed, Hazo, Pildash, Jidlaph, and Bethuel." **23** Bethuel became the father of Rebekah. These eight Milcah bore to Nahor, Abraham's brother. **24** His concubine, whose name was Reumah, also bore Tebah, Gaham, Tahash, and Maacah.

CHAPTER 23

Sarah lived one hundred twenty-seven years. This was the length of Sarah's life. **2** Sarah died in Kiriath Arba (also called Hebron), in the land of Canaan. Abraham came to mourn for Sarah, and to weep for her. **3** Abraham rose up from before his dead, and spoke to the children of Heth, saying, **4** "I am a stranger and a foreigner living with you. Give me a possession of a burying-place with you, that I may bury my dead out of my sight."

5 The children of Heth answered Abraham, saying to him, **6** "Hear us, my lord. You are a prince of God among us. Bury your dead in the best of our tombs. None of us will withhold from you his tomb. Bury your dead."

7 Abraham rose up, and bowed himself to the people of the land, even to the children of Heth. **8** He talked with them, saying, "If you agree that I should bury my dead out of my sight, hear me, and entreat for me to Ephron the son of Zohar, **9** that he may give me the cave of Machpelah, which he has, which is in the end of his field. For the full price let him give it to me among you for a possession of a burying-place."

10 Now Ephron was sitting in the middle of the children of Heth. Ephron the Hittite answered Abraham in the hearing of the children of Heth, even of all who went in at the gate of his city, saying, **11** "No, my lord, hear me. I give you the field, and I give you the cave that is in it. In the presence of the children of my people I give it to you. Bury your dead."

12 Abraham bowed himself down before the people of the land. **13** He spoke to Ephron in the audience of the people of the land, saying, "But if you will, please hear me. I will give the price of the field. Take it from me, and I will bury my dead there."

14 Ephron answered Abraham, saying to him, **15** "My lord, listen to me. What is a piece of land worth four hundred shekels of silver [*a shekel is about 10 grams, so 400 shekels would be about 4 kg or 8.8 pounds*] between me and you? Therefore bury your dead."

16 Abraham listened to Ephron. Abraham weighed to Ephron the silver which he had named in the audience of the children of Heth, four hundred shekels of silver, according to the current merchants' standard.

17 So the field of Ephron, which was in Machpelah, which was before Mamre, the field, the cave which was in it, and all the trees that were in the field, that were in all of its borders, were deeded **18** to Abraham for a possession in the presence of the children of Heth, before all who went in at the gate of his city. **19** After this, Abraham buried Sarah his wife in the cave of the field of Machpelah before Mamre (that is, Hebron), in the land of Canaan. **20** The field, and the cave that is in it, were deeded to Abraham as a possession for a burying place by the children of Heth.

The Burial of Sarah

Gustave Doré
19TH CENTURY

When his wife Sarah died at the age of 127, Abraham purchased some land and a cave in Hebron from Ephron the Hittite. In this engraving the bereaved Abraham stands in the mouth of the cave looking back at his wife's shrouded body as it is sealed in the tomb.

CHAPTERS 24–28

Abraham sends a servant to find a wife for his son Isaac; the servant returns with Rebekah (often spelled Rebecca). Abraham remarries, has more children, and dies at the age of 175. Esau, Isaac's firstborn son, sells his birthright to his brother Jacob in exchange for a bowl of stew. Esau is then angry after Jacob tricks their father into giving Jacob the traditional blessing of the firstborn, so Rebekah sends Jacob to live with her brother Laban. On the way, Jacob dreams of a ladder to heaven and God promises him future blessings.

CHAPTER 24

Abraham was old, and well stricken in age. The LORD had blessed Abraham in all things. **2** Abraham said to his servant, the elder of his house, who ruled over all that he had, "Please put your hand under my thigh. **3** I will make you swear by the LORD, the God of heaven and the God of the earth, that you shall not take a wife for my son of the daughters of the Canaanites, among whom I live. **4** But you shall go to my country, and to my relatives, and take a wife for my son Isaac."

5 The servant said to him, "What if the woman isn't willing to follow me to this land? Must I bring your son again to the land you came from?"

6 Abraham said to him, "Beware that you don't bring my son there again. **7** The LORD, the God of heaven, who took me from my father's house, and from the land of my birth, who spoke to me, and who swore to me, saying, 'I will give this land to your offspring. He will send his angel before you, and you shall take a wife for my son from there. **8** If the woman isn't willing to follow you, then you shall be clear from this oath to me. Only you shall not bring my son there again."

9 The servant put his hand under the thigh of Abraham his master, and swore to him concerning this matter. **10** The servant took ten camels, of his master's camels, and departed, having a variety of good things of his master's with him. He arose, and went to Mesopotamia, to the city of Nahor. **11** He made the camels kneel down outside the city by the well of water at the time of evening, the time that women go out to draw water. **12** He said, "LORD, the God of my master Abraham, please give me success today, and show kindness to my master Abraham. **13** Behold, I am standing by the spring of water. The daughters of the men of the city are coming out to draw water. **14** Let it happen, that the young lady to whom I will say, 'Please let down your pitcher, that I may drink,' and she will say, 'Drink, and I will also give your camels a drink,'—let her be the one you have appointed for your servant Isaac. By this I will know that you have shown kindness to my master."

15 Before he had finished speaking, behold, Rebekah came out, who was born to Bethuel the son of Milcah, the wife of Nahor, Abraham's brother, with her pitcher on her shoulder. **16** The young lady was very beautiful to look at, a virgin. No man had known her. She went down to the spring, filled her pitcher, and came up. **17** The servant ran to meet her, and said, "Please give me a drink, a little water from your pitcher."

18 She said, "Drink, my lord." She hurried, and let down her pitcher on her hand, and gave him drink. **19** When she had done giving him drink, she said, "I will also draw for your camels, until they have done drinking." **20** She hurried, and emptied her pitcher into the trough, and ran again to the well to draw, and drew for all his camels.

21 The man looked steadfastly at her, remaining silent, to know whether the LORD had made his journey prosperous or not. **22** As the camels had done drinking, the man took a golden ring of half a shekel weight [*a shekel is about 10 grams*], and two bracelets for her hands of ten shekels weight of gold, **23** and said, "Whose daughter are you? Please tell me. Is there room in your father's house for us to lodge in?"

24 She said to him, "I am the daughter of Bethuel the son of Milcah, whom she bore to Nahor." **25** She said moreover to him, "We have both straw and feed enough, and room to lodge in."

26 The man bowed his head, and worshiped the LORD. **27** He said, "Blessed be the LORD, the God of my master Abraham, who has not forsaken his loving kindness and his truth toward my master. As for me, the LORD has led me on the way to the house of my master's relatives."

28 The young lady ran, and told her mother's house about these words. **29** Rebekah had a brother, and his name was Laban. Laban ran out to the man, to the spring. **30** When he saw the ring, and the bracelets on his sister's hands, and when he heard the words of Rebekah his sister, saying, "This is what the man said to me," he came to the man. Behold, he was standing by the camels at the spring. **31** He said, "Come in, you blessed of the LORD. Why do you stand outside? For I have prepared the house, and room for the camels."

32 The man came into the house, and he unloaded the camels. He gave straw and feed for the camels, and water to wash his feet and the feet of the men who were with him. **33** Food was set before him to eat, but he said, "I will not eat until I have told my message."

He said, "Speak on."

34 He said, "I am Abraham's servant. **35** The LORD has blessed my master greatly. He has become great. He has given him flocks and herds, silver and gold, male servants and female servants, and camels and donkeys. **36** Sarah, my master's wife, bore a son to my master when she was old. He has given all that he has to him. **37** My master made me swear, saying, 'You shall not take a wife for my son from the daughters of the Canaanites, in whose land I live, **38** but you shall go to my father's house, and to my relatives, and take a wife for my son.' **39** I asked my master, 'What if the woman will not follow me?' **40** He said to me, 'The LORD, before whom I walk, will send his angel with you, and prosper your way. You shall take a wife for my son from my relatives, and of my father's house. **41** Then will you be clear from my oath, when you come to my relatives. If they don't give her to you, you shall be clear from my oath.' **42** I came today to the spring, and said, 'LORD, the God of my master Abraham, if now you do prosper my way which I go— **43** behold, I am standing by this spring of water. Let it happen, that the maiden who comes out to draw, to whom I will say, "Please give me a little water from your pitcher to drink," **44** and she will tell me, "Drink, and I will also draw for your camels,"—let her be the woman whom the LORD has appointed for my master's son.' **45** Before I had finished speaking in my heart, behold, Rebekah came out with her pitcher on her shoulder. She went down to the spring, and drew. I said to her, 'Please let me drink.' **46** She hurried and let down her pitcher from her shoulder, and said, 'Drink, and I will also give your camels a drink.' So I drank, and she also gave the camels a drink. **47** I asked her, and said, 'Whose daughter are you?' She said, 'The daughter of Bethuel, Nahor's son, whom Milcah bore to him.' I put the ring on her nose, and the bracelets on her hands. **48** I bowed my head, and worshiped the LORD, and blessed the LORD, the God of my master Abraham, who had led me in the right way to take my master's brother's daughter for his son. **49** Now if you will deal kindly and truly with my master, tell me. If not, tell me, that I may turn to the right hand, or to the left."

Rebecca and Eliezer

Sébastien Bourdon

17TH CENTURY

Abraham sent his servant Eliezer to his homeland of Canaan to find a wife for his son Isaac. Eliezer waited near a village well at the time when the women would come to draw water, praying that one of the women would offer a drink to him and his camels and that she would be God's chosen bride for Isaac. When Rebekah fulfilled this prayer, Eliezer gave her some jewelry—a ring and two bracelets, as shown in this painting— before going to Rebekah's home to negotiate the betrothal.

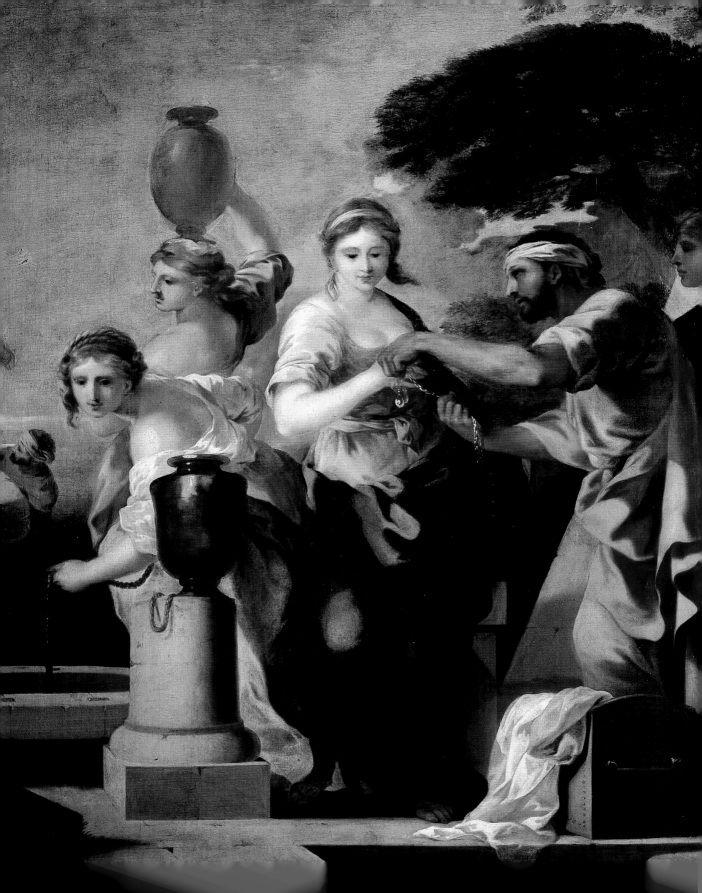

50 Then Laban and Bethuel answered, "The thing proceeds from the LORD. We can't speak to you bad or good. 51 Behold, Rebekah is before you. Take her, and go, and let her be your master's son's wife, as the LORD has spoken."

52 When Abraham's servant heard their words, he bowed himself down to the earth to the LORD. 53 The servant brought out jewels of silver, and jewels of gold, and clothing, and gave them to Rebekah. He also gave precious things to her brother and her mother. 54 They ate and drank, he and the men who were with him, and stayed all night. They rose up in the morning, and he said, "Send me away to my master."

55 Her brother and her mother said, "Let the young lady stay with us a few days, at least ten. After that she will go."

56 He said to them, "Don't hinder me, since the LORD has prospered my way. Send me away that I may go to my master."

57 They said, "We will call the young lady, and ask her." 58 They called Rebekah, and said to her, "Will you go with this man?"

She said, "I will go."

59 They sent away Rebekah, their sister, with her nurse, Abraham's servant, and his men. 60 They blessed Rebekah, and said to her, "Our sister, may you be the mother of thousands of ten thousands, and let your offspring possess the gate of those who hate them."

61 Rebekah arose with her ladies. They rode on the camels, and followed the man. The servant took Rebekah, and went his way.

The Wedding Feast of Isaac and Rebecca

Pedro Orrente
17TH CENTURY

The beautiful Rebekah agreed to leave her family and travel to a new land to marry Isaac, a man she had never even seen. Genesis says that the bereaved Isaac loved Rebekah and found comfort in her over his mother's death.

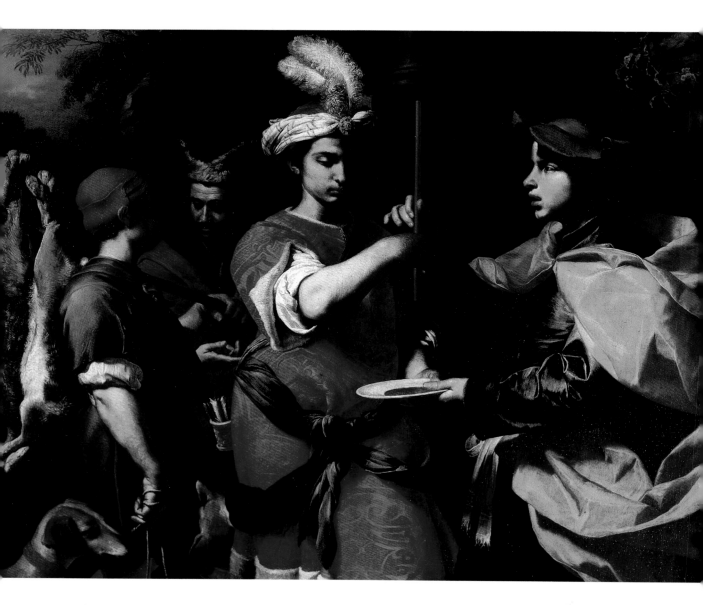

Esau Selling His Birthright to Jacob

Francesco Guarino

17TH CENTURY

Esau and Jacob were fraternal twins, with Esau having the greater birthright of the firstborn. Returning home famished after a day's hunting, Esau asked Jacob for some of the red stew he had cooked. Jacob agreed on condition that Esau would give his birthright to Jacob in return. Esau stands at the center of the painting—dressed in red, the color associated with him because he was born covered in red hair and the stew was red—as Jacob hands him the bowl of food. Above the bowl, they exchange a rod with their right hands, with Jacob's hand higher than Esau's, symbolic of Esau ceding his birthright to Jacob.

62 Isaac came from the way of Beer Lahai Roi, for he lived in the land of the South. **63** Isaac went out to meditate in the field at the evening. He lifted up his eyes, and saw, and, behold, there were camels coming. **64** Rebekah lifted up her eyes, and when she saw Isaac, she dismounted from the camel. **65** She said to the servant, "Who is the man who is walking in the field to meet us?"

The servant said, "It is my master."

She took her veil, and covered herself. **66** The servant told Isaac all the things that he had done. **67** Isaac brought her into his mother Sarah's tent, and took Rebekah, and she became his wife. He loved her. Isaac was comforted after his mother's death.

CHAPTER 25

Abraham took another wife, and her name was Keturah. **2** She bore him Zimran, Jokshan, Medan, Midian, Ishbak, and Shuah. **3** Jokshan became the father of Sheba, and Dedan. The sons of Dedan were Asshurim, Letushim, and Leummim. **4** The sons of Midian were: Ephah, Epher, Hanoch, Abida, and Eldaah. All these were the children of Keturah. **5** Abraham gave all that he had to Isaac, **6** but to the sons of Abraham's concubines, Abraham gave gifts. He sent them away from Isaac his son, while he yet lived, eastward, to the east country. **7** These are the days of the years of Abraham's life which he lived: one hundred seventy-five years. **8** Abraham gave up his spirit, and died in a good old age, an old man, and full of years, and was gathered to his people. **9** Isaac and Ishmael, his sons, buried him in the cave of Machpelah, in the field of Ephron, the son of Zohar the Hittite, which is before Mamre, **10** the field which Abraham purchased of the children of Heth. Abraham was buried there with Sarah, his wife. **11** After the death of Abraham, God blessed Isaac, his son. Isaac lived near Beer Lahai Roi.

12 Now this is the history of the generations of Ishmael, Abraham's son, whom Hagar the Egyptian, Sarah's servant, bore to Abraham. **13** These are the names of the sons of Ishmael, by their names, according to the order of their birth: the firstborn of Ishmael, Nebaioth, then Kedar, Adbeel, Mibsam, **14** Mishma, Dumah, Massa, **15** Hadad, Tema, Jetur, Naphish, and Kedemah. **16** These are the sons of Ishmael, and these are their names, by their villages, and by their encampments: twelve princes, according to their nations. **17** These are the years of the life of Ishmael: one hundred thirty-seven years. He gave up his spirit and died, and was gathered to his people. **18** They lived from Havilah to Shur that is before Egypt, as you go toward Assyria. He lived opposite all his relatives.

19 This is the history of the generations of Isaac, Abraham's son. Abraham became the father of Isaac. **20** Isaac was forty years old when he took Rebekah, the daughter of Bethuel the Syrian of Paddan Aram, the sister of Laban the Syrian, to be his wife. **21** Isaac entreated the LORD for his wife, because she was barren. The LORD was entreated by him, and Rebekah his wife conceived. **22** The children struggled together within her. She said, "If it is so, why do I live?" She went to inquire of the LORD. **23** The LORD said to her,

"Two nations are in your womb.
Two peoples will be separated from
 your body.
The one people will be stronger than
 the other people.
The elder will serve the younger."

24 When her days to be delivered were fulfilled, behold, there were twins in her womb. **25** The first came out red all over, like a hairy garment. They named him Esau. **26** After that, his brother came out, and his hand had hold on Esau's heel. He was named Jacob. Isaac was sixty years old when she bore them.

27 The boys grew. Esau was a skillful hunter, a man of the field. Jacob was a quiet man, living in tents. **28** Now Isaac loved Esau, because he ate his venison. Rebekah loved Jacob. **29** Jacob boiled stew. Esau came in from the field, and he was famished. **30** Esau said to Jacob, "Please feed me with that same red stew, for I am famished." Therefore his name was called Edom [*"red"*].

31 Jacob said, "First, sell me your birthright."

32 Esau said, "Behold, I am about to die. What good is the birthright to me?"

33 Jacob said, "Swear to me first."

He swore to him. He sold his birthright to Jacob. **34** Jacob gave Esau bread and stew of lentils. He ate and drank, rose up, and went his way. So Esau despised his birthright.

> *The LORD appeared to him [Isaac], and said… "For I will give to you, and to your offspring, all these lands, and I will establish the oath which I swore to Abraham your father. I will multiply your offspring as the stars of the sky, and will give all these lands to your offspring. In your offspring will all the nations of the earth be blessed, because Abraham obeyed my voice, and kept my requirements, my commandments, my statutes, and my laws."*
>
> Genesis 26:2–5

CHAPTER 26

There was a famine in the land, besides the first famine that was in the days of Abraham. Isaac went to Abimelech king of the Philistines, to Gerar. **2** The LORD appeared to him, and said, "Don't go down into Egypt. Live in the land I will tell you about. **3** Live in this land, and I will be with you, and will bless you. For I will give to you, and to your offspring, all these lands, and I will establish the oath which I swore to Abraham your father. **4** I will multiply your offspring as the stars of the sky, and will give all these lands to your offspring. In your offspring will all the nations of the earth be blessed, **5** because Abraham obeyed my voice, and kept my requirements, my commandments, my statutes, and my laws."

6 Isaac lived in Gerar. **7** The men of the place asked him about his wife. He said, "She is my sister," for he was afraid to say, "My wife", lest, he thought, "the men of the place might kill me for Rebekah, because she is beautiful to look at." **8** When he had been there a long time, Abimelech king of the Philistines looked out at a window, and saw, and, behold, Isaac was caressing Rebekah, his wife. **9** Abimelech called Isaac, and said, "Behold, surely she is your wife. Why did you say, 'She is my sister?'"

Isaac said to him, "Because I said, 'Lest I die because of her.'"

10 Abimelech said, "What is this you have done to us? One of the people might easily have lain with your wife, and you would have brought guilt on us!"

11 Abimelech commanded all the people, saying, "He who touches this man or his wife will surely be put to death."

12 Isaac sowed in that land, and reaped in the same year one hundred times what he planted. The LORD blessed him. **13** The man grew great, and grew more and more until he became very great. **14** He had possessions of flocks, possessions of herds, and a great household. The Philistines envied him. **15** Now all the wells which his father's servants had dug in the days of Abraham his father, the Philistines had stopped, and filled with earth. **16** Abimelech said to Isaac, "Go from us, for you are much mightier than we."

17 Isaac departed from there, encamped in the valley of Gerar, and lived there.

18 Isaac dug again the wells of water, which they had dug in the days of Abraham his father. For the Philistines had stopped them after the death of Abraham. He called their names after the names by which his father had called them. **19** Isaac's servants dug in the valley, and found there a well of springing water. **20** The herdsmen of Gerar argued with Isaac's herdsmen, saying, "The water is ours." He called the name of the well Esek, because they contended with him. **21** They dug another well, and they argued over that, also. He called its name Sitnah. **22** He left that place, and dug another well. They didn't argue over that one. He called it Rehoboth. He said, "For now the LORD has made room for us, and we will be fruitful in the land."

23 He went up from there to Beersheba. **24** The LORD appeared to him the same night, and said, "I am the God of Abraham your father. Don't be afraid, for I am with you, and will bless you, and multiply your offspring for my servant Abraham's sake."

25 He built an altar there, and called on the LORD's name, and pitched his tent there. There Isaac's servants dug a well.

26 Then Abimelech went to him from Gerar, and Ahuzzath his friend, and Phicol the captain of his army. **27** Isaac said to them, "Why have you come to me, since you hate me, and have sent me away from you?"

28 They said, "We saw plainly that the LORD was with you. We said, 'Let there now be an oath between us, even between us and you, and let us make a covenant with you, **29** that you will do us no harm, as we have not touched you, and as we have done to you nothing but good, and have sent you away in peace.' You are now the blessed of the LORD."

30 He made them a feast, and they ate and drank. **31** They rose up some time in the morning, and swore to one another. Isaac sent them away, and they departed from him in peace. **32** The same day, Isaac's servants came, and told him concerning the well which they had dug, and said to him, "We have found water." **33** He called it Shibah [*"oath" or "seven"*]. Therefore the name of the city is Beersheba [*"well of the oath" or "well of the seven"*] to this day.

34 When Esau was forty years old, he took as wife Judith, the daughter of Beeri the Hittite, and Basemath, the daughter of Elon the Hittite. **35** They grieved Isaac's and Rebekah's spirits.

CHAPTER 27

When Isaac was old, and his eyes were dim, so that he could not see, he called Esau his elder son, and said to him, "My son?" He said to him, "Here I am."

2 He said, "See now, I am old. I don't know the day of my death. **3** Now therefore, please take your weapons, your quiver and your bow, and go out to the field, and take me venison. **4** Make me savory food, such as I love, and bring it to me, that I may eat, and that my soul may bless you before I die."

5 Rebekah heard when Isaac spoke to Esau his son. Esau went to the field to hunt for venison, and to bring it. **6** Rebekah spoke to Jacob her son, saying, "Behold, I heard your father speak to Esau your brother, saying, **7** 'Bring me venison, and make me savory food, that I may eat, and bless you before the LORD before my death.' **8** Now therefore, my son, obey my voice according to that which I command you. **9** Go now to the flock, and get me from there two good young goats. I will make them savory food for your father, such as he loves. **10** You shall bring it to your father, that he may eat, so that he may bless you before his death."

11 Jacob said to Rebekah his mother, "Behold, Esau my brother is a hairy man, and I am a smooth man. **12** What if my father touches me? I will seem to him as a deceiver, and I would bring a curse on myself, and not a blessing."

13 His mother said to him, "Let your curse be on me, my son. Only obey my voice, and go get them for me."

14 He went, and got them, and brought them to his mother. His mother made savory food, such as his father loved. **15** Rebekah took the good clothes of Esau, her elder son, which were with her in the house, and put them on Jacob, her younger son. **16** She put the skins of the young goats on his hands, and on the smooth of his neck. **17** She gave the savory food and the bread, which she had prepared, into the hand of her son Jacob.

18 He came to his father, and said, "My father?"

He said, "Here I am. Who are you, my son?"

19 Jacob said to his father, "I am Esau your firstborn. I have done what you asked me to

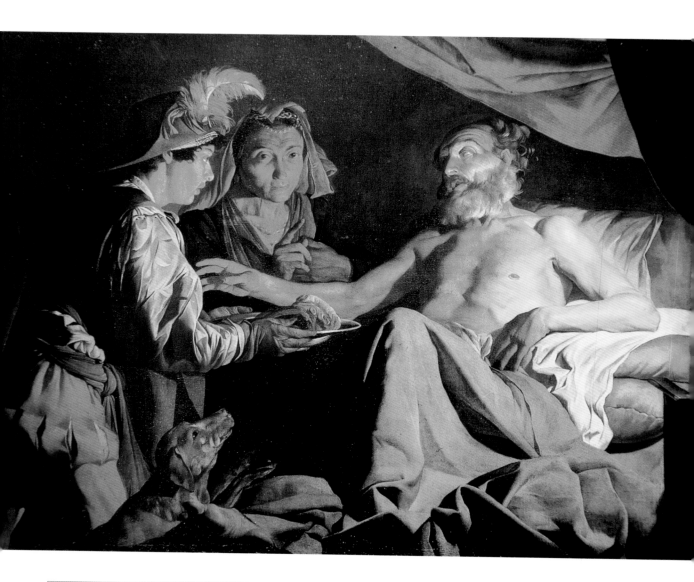

Isaac Blessing Jacob

Matthias Stom

c. 1635

When Isaac grew old and became blind, he told his son Esau to hunt some game and prepare his favorite food, and then he would give Esau the blessing of the firstborn. Isaac's wife Rebekah helped Jacob, the second-born son and her favorite, to disguise himself as Esau in order to trick Isaac into giving him the blessing. In this painting a frail Isaac reaches out his right hand to give the blessing, while a fearful Jacob holds out a bowl of food, wearing goatskin gloves to hide his smooth skin and make it feel like that of his hairy sibling. Rebekah stands at the center of the scene, raising a finger for silence.

do. Please arise, sit and eat of my venison, that your soul may bless me."

20 Isaac said to his son, "How is it that you have found it so quickly, my son?"

He said, "Because the LORD your God gave me success."

21 Isaac said to Jacob, "Please come near, that I may feel you, my son, whether you are really my son Esau or not."

22 Jacob went near to Isaac his father. He felt him, and said, "The voice is Jacob's voice, but the hands are the hands of Esau." **23** He did not recognize him, because his hands were hairy, like his brother, Esau's hands. So he blessed him. **24** He said, "Are you really my son Esau?"

He said, "I am."

25 He said, "Bring it near to me, and I will eat of my son's venison, that my soul may bless you."

He brought it near to him, and he ate. He brought him wine, and he drank. **26** His father Isaac said to him, "Come near now, and kiss me, my son." **27** He came near, and kissed him. He smelled the smell of his clothing, and blessed him, and said,

"Behold, the smell of my son
 is as the smell of a field which
 the LORD has blessed.
28 God give you of the dew of the sky,
 of the fatness of the earth,
 and plenty of grain and new wine.
29 Let peoples serve you,
 and nations bow down to you.
Be lord over your brothers.
 Let your mother's sons bow down to you.
 Cursed be everyone who curses you.
 Blessed be everyone who blesses you."

30 As soon as Isaac had finished blessing Jacob, and Jacob had just gone out from the presence of Isaac his father, Esau his brother came in from his hunting. **31** He also made savory food, and brought it to his father. He said to his father, "Let my father arise, and eat of his son's venison, that your soul may bless me."

32 Isaac his father said to him, "Who are you?"

He said, "I am your son, your firstborn, Esau."

33 Isaac trembled violently, and said, "Who, then, is he who has taken venison, and brought it me, and I have eaten of all before you came, and have blessed him? Yes, he will be blessed."

34 When Esau heard the words of his father, he cried with an exceeding great and bitter cry, and said to his father, "Bless me, even me also, my father."

35 He said, "Your brother came with deceit, and has taken away your blessing."

36 He said, "Isn't he rightly named Jacob? [*Jacob means "he grasps the heel," a Hebrew idiom for "he takes advantage of" or "he deceives."*] For he has supplanted me these two times. He took away my birthright. See, now he has taken away my blessing." He said, "Haven't you reserved a blessing for me?"

37 Isaac answered Esau, "Behold, I have made him your lord, and all his brothers have I given to him for servants. With grain and new wine have I sustained him. What then will I do for you, my son?"

38 Esau said to his father, "Have you but one blessing, my father? Bless me, even me also, my father." Esau lifted up his voice, and wept.

39 Isaac his father answered him:
 "Behold, of the fatness of the earth
 will be your dwelling,
 and of the dew of the sky from above.
40 By your sword will you live,
 and you will serve your brother.
 It will happen, when you will break loose,
 that you shall shake his yoke
 from off your neck."

41 Esau hated Jacob because of the blessing with which his father blessed him. Esau said in his heart, "The days of mourning for my father are at hand. Then I will kill my brother Jacob."

42 The words of Esau, her elder son, were told to Rebekah. She sent and called Jacob, her younger son, and said to him, "Behold, your brother Esau comforts himself about you by planning to kill you. **43** Now therefore, my son, obey my voice. Arise, flee to Laban, my brother, in Haran. **44** Stay with him a few days, until your brother's fury turns away; **45** until your brother's anger turn away from you, and he forgets what you have done to him. Then I will send, and get you from there. Why should I be bereaved of you both in one day?"

46 Rebekah said to Isaac, "I am weary of my life because of the daughters of Heth. If Jacob takes a wife of the daughters of Heth, such as these, of the daughters of the land, what good will my life do me?"

CHAPTER 28

Isaac called Jacob, blessed him, and commanded him, "You shall not take a wife of the daughters of Canaan. **2** Arise, go to Paddan Aram, to the house of Bethuel your mother's father. Take a wife from there from the daughters of Laban, your mother's brother. **3** May God Almighty bless you, and make you fruitful, and multiply you, that you may be a company of peoples, **4** and give you the blessing of Abraham, to you, and to your offspring with you, that you may inherit the land where you travel, which God gave to Abraham."

5 Isaac sent Jacob away. He went to Paddan Aram to Laban, son of Bethuel the Syrian, Rebekah's brother, Jacob's and Esau's mother.

6 Now Esau saw that Isaac had blessed Jacob and sent him away to Paddan Aram, to take him a wife from there, and that as he blessed him he gave him a command, saying, "You shall not take a wife of the daughters of Canaan," **7** and that Jacob obeyed his father and his mother, and was gone to Paddan Aram. **8** Esau saw that the daughters of Canaan didn't please Isaac, his father. **9** Esau went to Ishmael, and took, besides the wives that he had, Mahalath the daughter of Ishmael, Abraham's son, the sister of Nebaioth, to be his wife.

10 Jacob went out from Beersheba, and went toward Haran. **11** He came to a certain place, and stayed there all night, because the sun had set. He took one of the stones of the place, and put it under his head, and lay down in that place to sleep. **12** He dreamed. Behold, a stairway set upon the earth, and its top reached to heaven. Behold, the angels of God ascending and descending on it. **13** Behold, the LORD stood above it, and said, "I am the LORD, the God of Abraham your father, and the God of Isaac. The land whereon you lie, to you will I give it, and to your offspring. **14** Your offspring will be as the dust of the earth, and you will spread abroad to the west, and to the east, and to the north, and to the south. In you and in your offspring will all the families of the earth be blessed. **15** Behold, I am with you, and will keep you, wherever you go, and will bring you again into this land. For I will not leave you, until I have done that which I have spoken of to you."

16 Jacob awakened out of his sleep, and he said, "Surely the LORD is in this place, and I didn't know it." **17** He was afraid, and said, "How dreadful is this place! This is none other than God's house, and this is the gate of heaven."

18 Jacob rose up early in the morning, and took the stone that he had put under his head, and set it up for a pillar, and poured oil on its top. **19** He called the name of that place Bethel, but the name of the city was Luz previously. **20** Jacob vowed a vow, saying, "If God will be with me, and will keep me in this way that I go, and will give me bread to eat, and clothing to put on, **21** so that I come again to my father's house in peace, and the LORD will be my God, **22** then this stone, which I have set up for a pillar, will be God's house. Of all that you will give me I will surely give a tenth to you."

Jacob's Ladder

William Blake
1800

Esau was murderously angry after his brother Jacob tricked their father into giving Jacob the blessing of the firstborn that should have gone to Esau. To get away, Jacob went to live with his uncle Laban. During the journey, Jacob dreamed that he saw angels going up and down a stairway (or ladder) into heaven and that God, standing at the top, promised to take care of Jacob while he was away from his homeland. In this watercolor Jacob lies sleeping at the foot of the stairway.

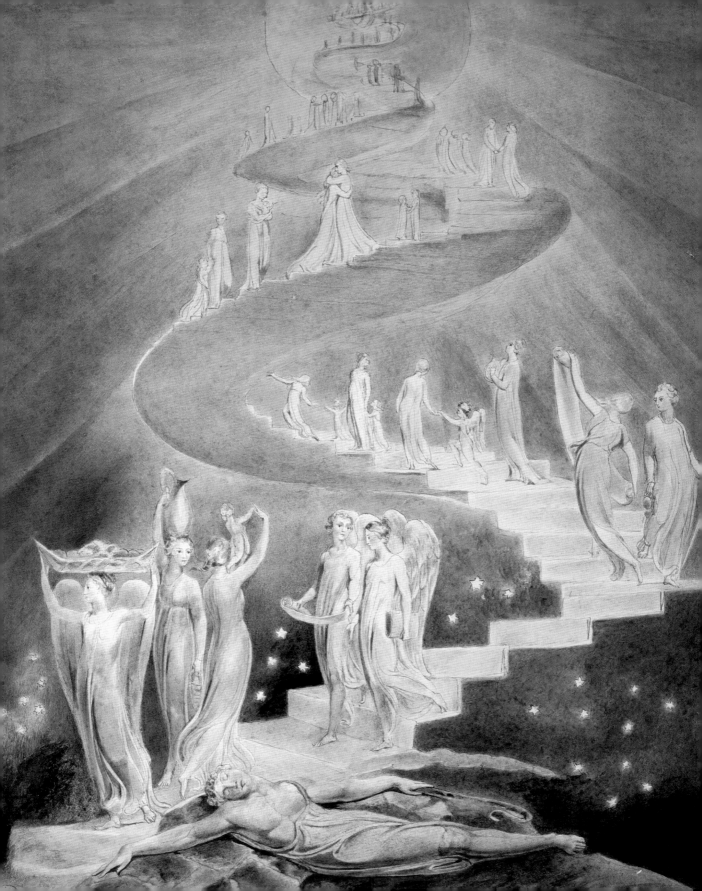

CHAPTERS 29—31

Jacob works for seven years for his uncle Laban in order to marry Laban's daughter, Rachel, but Laban tricks him into marrying her sister Leah, too. Leah bears Jacob four sons, but Rachel remains childless. Rachel's servant Bilhah and Leah's servant Zilpah also marry Jacob. Leah, Bilhah, and Zilpah give birth to six more sons and a daughter before Rachel finally bears Joseph. After working for about twenty years for Laban, Jacob and his family sneak off to Canaan. An angry Laban pursues them, but finally makes a peace treaty with Jacob.

CHAPTER 29

Then Jacob went on his journey, and came to the land of the children of the east. **²** He looked, and behold, a well in the field, and, behold, three flocks of sheep lying there by it. For out of that well they watered the flocks. The stone on the well's mouth was large. **³** There all the flocks were gathered. They rolled the stone from the well's mouth, and watered the sheep, and put the stone again on the well's mouth in its place. **⁴** Jacob said to them, "My relatives, where are you from?"

They said, "We are from Haran."

⁵ He said to them, "Do you know Laban, the son of Nahor?"

They said, "We know him."

⁶ He said to them, "Is it well with him?"

They said, "It is well. See, Rachel, his daughter, is coming with the sheep."

⁷ He said, "Behold, it is still the middle of the day, not time to gather the livestock together. Water the sheep, and go and feed them."

⁸ They said, "We can't, until all the flocks are gathered together, and they roll the stone from the well's mouth. Then we water the sheep."

⁹ While he was yet speaking with them, Rachel came with her father's sheep, for she kept them. **¹⁰** When Jacob saw Rachel the daughter of Laban, his mother's brother, and the sheep of Laban, his mother's brother, Jacob went near, and rolled the stone from the well's mouth, and watered the flock of Laban his mother's brother. **¹¹** Jacob kissed Rachel, and lifted up his voice, and wept. **¹²** Jacob told Rachel that he was her father's brother, and that he was Rebekah's son. She ran and told her father.

¹³ When Laban heard the news of Jacob, his sister's son, he ran to meet Jacob, and embraced him, and kissed him, and brought him to his house. Jacob told Laban all these things. **¹⁴** Laban said to him, "Surely you are my bone and my flesh." He lived with him for a month. **¹⁵** Laban said to Jacob, "Because you are my brother, should you therefore serve me for nothing? Tell me, what will your wages be?"

¹⁶ Laban had two daughters. The name of the elder was Leah, and the name of the younger was Rachel. **¹⁷** Leah's eyes were weak, but Rachel was beautiful in form and attractive. **¹⁸** Jacob loved Rachel. He said, "I will serve you seven years for Rachel, your younger daughter."

¹⁹ Laban said, "It is better that I give her to you, than that I should give her to another man. Stay with me."

²⁰ Jacob served seven years for Rachel. They seemed to him but a few days, for the love he had for her.

²¹ Jacob said to Laban, "Give me my wife, for my days are fulfilled, that I may go in to her."

²² Laban gathered together all the men of the place, and made a feast. **²³** In the evening, he took Leah his daughter, and brought her to him. He went in to her. **²⁴** Laban gave Zilpah his servant to his daughter Leah for a servant. **²⁵** In the morning, behold, it was Leah. He said to Laban, "What is this you have done to me? Didn't I serve with you for Rachel? Why then have you deceived me?"

²⁶ Laban said, "It is not done so in our place, to give the younger before the firstborn. **²⁷** Fulfill the week of this one, and we will give you the other also for the service which you will serve with me yet seven other years."

28 Jacob did so, and fulfilled her week. He gave him Rachel his daughter as wife. **29** Laban gave to Rachel his daughter Bilhah, his servant, to be her servant. **30** He went in also to Rachel, and he loved also Rachel more than Leah, and served with him yet seven other years.

31 The Lord saw that Leah was hated, and he opened her womb, but Rachel was barren. **32** Leah conceived, and bore a son, and she named him Reuben. For she said, "Because the Lord has looked at my affliction. For now my husband will love me." **33** She conceived again, and bore a son, and said, "Because the Lord has heard that I am hated, he has therefore given me this son also." She named him Simeon. **34** She conceived again, and bore a son. Said, "Now this time will my husband be joined to me, because I have borne him three sons." Therefore his name was called Levi. **35** She conceived again, and bore a son. She said, "This time will I praise the Lord." Therefore she named him Judah. Then she stopped bearing.

Leah

Ricciardo Meacci
1882

Leah was the first of Jacob's four wives. She was not as beautiful as her sister Rachel, and her father had to trick Jacob into marrying Leah before allowing Jacob to marry Rachel, the woman he loved, as well. As consolation for the fact that she was not loved, God made Leah fertile. She was the mother of six of Jacob's sons, including the firstborn Reuben, and a daughter named Dinah.

CHAPTER 30

When Rachel saw that she bore Jacob no children, Rachel envied her sister. She said to Jacob, "Give me children, or else I will die."

2 Jacob's anger burned against Rachel, and he said, "Am I in God's place, who has withheld from you the fruit of the womb?"

3 She said, "Behold, my maid Bilhah. Go in to her, that she may bear on my knees, and I also may obtain children by her." **4** She gave him Bilhah her servant as wife, and Jacob went in to her. **5** Bilhah conceived, and bore Jacob a son. **6** Rachel said, "God has judged me, and has also heard my voice, and has given me a son." Therefore called she his name Dan. **7** Bilhah, Rachel's servant, conceived again, and bore Jacob a second son. **8** Rachel said, "With mighty wrestlings have I wrestled with my sister, and have prevailed." She named him Naphtali.

9 When Leah saw that she had finished bearing, she took Zilpah, her servant, and gave her to Jacob as a wife. **10** Zilpah, Leah's servant, bore Jacob a son. **11** Leah said, "How fortunate!" She named him Gad. **12** Zilpah, Leah's servant, bore Jacob a second son. **13** Leah said, "Happy am I, for the daughters will call me happy." She named him Asher.

14 Reuben went in the days of wheat harvest, and found mandrakes in the field, and brought them to his mother, Leah. Then Rachel said to Leah, "Please give me some of your son's mandrakes."

15 She said to her, "Is it a small matter that you have taken away my husband? Would you take away my son's mandrakes, also?"

Rachel said, "Therefore he will lie with you tonight for your son's mandrakes."

16 Jacob came from the field in the evening, and Leah went out to meet him, and said, "You must come in to me; for I have surely hired you with my son's mandrakes."

He lay with her that night. **17** God listened to Leah, and she conceived, and bore Jacob a fifth son. **18** Leah said, "God has given me my reward, because I gave my servant to my husband." She named him Issachar. **19** Leah conceived again, and bore a sixth son to Jacob. **20** Leah said, "God has endowed me with a good dowry. Now my husband will live with me, because I have borne him six sons." She

Whenever the stronger of the flock conceived, Jacob laid the rods in front of the eyes of the flock in the gutters, that they might conceive among the rods; but when the flock were feeble, he didn't put them in. So the feebler were Laban's, and the stronger Jacob's.

Genesis 30:41–42

named him Zebulun. ²¹ Afterward, she bore a daughter, and named her Dinah.

²² God remembered Rachel, and God listened to her, and opened her womb. ²³ She conceived, bore a son, and said, "God has taken away my reproach." ²⁴ She named him Joseph, saying, "May the LORD add another son to me."

²⁵ When Rachel had borne Joseph, Jacob said to Laban, "Send me away, that I may go to my own place, and to my country. ²⁶ Give me my wives and my children for whom I have served you, and let me go; for you know my service with which I have served you."

²⁷ Laban said to him, "If now I have found favor in your eyes, stay here, for I have divined that the LORD has blessed me for your sake." ²⁸ He said, "Appoint me your wages, and I will give it."

²⁹ He said to him, "You know how I have served you, and how your livestock have fared with me. ³⁰ For it was little which you had before I came, and it has increased to a multitude. The LORD has blessed you wherever I turned. Now when will I provide for my own house also?"

³¹ He said, "What shall I give you?"

Jacob said, "You shall not give me anything. If you will do this thing for me, I will again feed your flock and keep it. ³² I will pass through all your flock today, removing from there every speckled and spotted one, and every black one among the sheep, and the spotted and speckled among the goats.

This will be my wages. ³³ So my righteousness will answer for me hereafter, when you come concerning my wages that is before you. Every one that is not speckled and spotted among the goats, and black among the sheep, that might be with me, will be considered stolen."

³⁴ Laban said, "Behold, let it be according to your word."

³⁵ That day, he removed the male goats that were streaked and spotted, and all the female goats that were speckled and spotted, every one that had white in it, and all the black ones among the sheep, and gave them into the hand of his sons. ³⁶ He set three days' journey between himself and Jacob, and Jacob fed the rest of Laban's flocks.

³⁷ Jacob took to himself rods of fresh poplar, almond, plane tree, peeled white streaks in them, and made the white appear which was in the rods. ³⁸ He set the rods which he had peeled opposite the flocks in the gutters in the watering-troughs where the flocks came to drink. They conceived when they came to drink. ³⁹ The flocks conceived before the rods, and the flocks produced young that were streaked, speckled, and spotted. ⁴⁰ Jacob separated the lambs, and set the faces of the flocks toward the streaked and all the black in the flock of Laban: and he put his own droves apart, and did not put them into Laban's flock. ⁴¹ Whenever the stronger of the flock conceived, Jacob laid the rods in front of the eyes of the flock in the gutters, that they might conceive among the rods; ⁴² but when

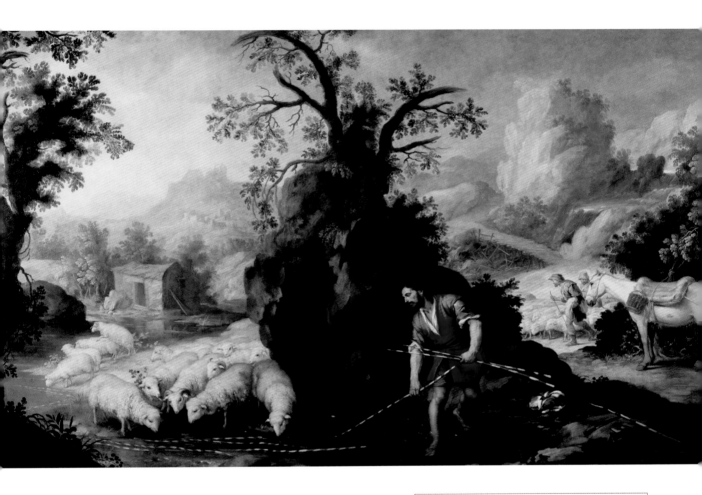

the flock were feeble, he didn't put them in.
So the feebler were Laban's, and the stronger
Jacob's. **43** The man increased exceedingly, and
had large flocks, female servants and male
servants, and camels and donkeys.

CHAPTER 31

He heard the words of Laban's
sons, saying, "Jacob has taken
away all that was our father's.
From that which was our father's,
has he gotten all this wealth." **2** Jacob saw the
expression on Laban's face, and, behold, it was
not toward him as before. **3** The LORD said to
Jacob, "Return to the land of your fathers, and
to your relatives, and I will be with you."

4 Jacob sent and called Rachel and Leah
to the field to his flock, **5** and said to them,

Jacob Laying Peeled Rods Before the Flocks of Laban

Bartolomé Esteban Murillo
c. 1665

Jacob negotiated an agreement with
his father-in-law Laban that he would
continue tending to Laban's flock of
sheep and goats, but that any streaked,
speckled, spotted, or black animals
born in the future would become
Jacob's wages. Jacob then placed rods
of wood, with the bark peeled to give
them a white-streaked pattern, around
the watering places of the best-quality
animals to influence the color of the
newborns they would conceive.

> *Laban said to Jacob, "What have you done, that you have deceived me, and carried away my daughters like captives of the sword? Why did you flee secretly, and deceive me, and didn't tell me, that I might have sent you away with mirth and with songs, with tambourine and with harp; and didn't allow me to kiss my sons and my daughters? Now have you done foolishly."*
>
> Genesis 31:26–28

"I see the expression on your father's face, that it is not toward me as before; but the God of my father has been with me. **6** You know that I have served your father with all of my strength. **7** Your father has deceived me, and changed my wages ten times, but God didn't allow him to hurt me. **8** If he said this, 'The speckled will be your wages,' then all the flock bore speckled. If he said this, 'The streaked will be your wages,' then all the flock bore streaked. **9** Thus God has taken away your father's livestock, and given them to me. **10** During mating season, I lifted up my eyes, and saw in a dream, and behold, the male goats which leaped on the flock were streaked, speckled, and grizzled. **11** The angel of God said to me in the dream, 'Jacob,' and I said, 'Here I am.' **12** He said, 'Now lift up your eyes, and behold, all the male goats which leap on the flock are streaked, speckled, and grizzled, for I have seen all that Laban does to you. **13** I am the God of Bethel, where you anointed a pillar, where you vowed a vow to me. Now arise, get out from this land, and return to the land of your birth.'"

14 Rachel and Leah answered him, "Is there yet any portion or inheritance for us in our father's house? **15** Aren't we accounted by him as foreigners? For he has sold us, and has also quite devoured our money. **16** For all the riches which God has taken away from our father, that is ours and our children's. Now then, whatever God has said to you, do."

17 Then Jacob rose up, and set his sons and his wives on the camels, **18** and he took away all his livestock, and all his possessions which he had gathered, including the livestock which he had gained in Paddan Aram, to go to Isaac his father, to the land of Canaan. **19** Now Laban had gone to shear his sheep: and Rachel stole the teraphim [*household idols probably associated with inheritance rights to the household property*] that were her father's.

20 Jacob deceived Laban the Syrian, in that he didn't tell him that he was running away. **21** So he fled with all that he had. He rose up, passed over the River, and set his face toward the mountain of Gilead.

22 Laban was told on the third day that Jacob had fled. **23** He took his relatives with him, and pursued him seven days' journey. He overtook him in the mountain of Gilead. **24** God came to Laban, the Syrian, in a dream

of the night, and said to him, "Be careful that you don't speak to Jacob either good or bad."

25 Laban caught up with Jacob. Now Jacob had pitched his tent in the mountain, and Laban with his relatives encamped in the mountain of Gilead. **26** Laban said to Jacob, "What have you done, that you have deceived me, and carried away my daughters like captives of the sword? **27** Why did you flee secretly, and deceive me, and didn't tell me, that I might have sent you away with mirth and with songs, with tambourine and with harp; **28** and didn't allow me to kiss my sons and my daughters? Now have you done foolishly. **29** It is in the power of my hand to hurt you, but the God of your father spoke to me last night, saying, 'Be careful that you don't speak to Jacob either good or bad.' **30** Now, you want to be gone, because you greatly longed for your father's house, but why have you stolen my gods?"

31 Jacob answered Laban, "Because I was afraid, for I said, 'Lest you should take your daughters from me by force.' **32** Anyone you find your gods with shall not live. Before our relatives, discern what is yours with me, and take it." For Jacob did not know that Rachel had stolen them.

33 Laban went into Jacob's tent, into Leah's tent, and into the tent of the two female servants; but he did not find them. He went out of Leah's tent, and entered into Rachel's tent. **34** Now Rachel had taken the teraphim, put them in the camel's saddle, and sat on them. Laban felt around all the tent, but did not find them. **35** She said to her father, "Don't let my lord be angry that I can't rise up before you; for I'm having my period." He searched, but did not find the teraphim.

36 Jacob was angry, and argued with Laban. Jacob answered Laban, "What is my trespass? What is my sin, that you have hotly pursued me? **37** Now that you have felt around in all my stuff, what have you found of all your household stuff? Set it here before my relatives and your relatives, that they may judge between us two.

38 "These twenty years I have been with you. Your ewes and your female goats have not cast their young, and I haven't eaten the rams of your flocks. **39** That which was torn of animals, I didn't bring to you. I bore its loss. Of my hand you required it, whether stolen by day or stolen by night. **40** This was my situation: in the day the drought consumed me, and the frost by night; and my sleep fled from my eyes. **41** These twenty years I have been in your house. I served you fourteen years for your two daughters, and six years for your flock, and you have changed my wages ten times. **42** Unless the God of my father, the God of Abraham, and the fear of Isaac, had been with me, surely now you would have sent me away empty. God has seen my affliction and the labor of my hands, and rebuked you last night."

43 Laban answered Jacob, "The daughters are my daughters, the children are my children, the flocks are my flocks, and all that you see is mine: and what can I do today to these my daughters, or to their children whom they have borne? **44** Now come, let us make a covenant, you and I; and let it be for a witness between me and you."

45 Jacob took a stone, and set it up for a pillar. **46** Jacob said to his relatives, "Gather stones." They took stones, and made a heap. They ate there by the heap. **47** Laban called it Jegar Sahadutha [*"witness heap" in Aramaic*], but Jacob called it Galeed [*"witness heap" in Hebrew*]. **48** Laban said, "This heap is witness between me and you today." Therefore it was named Galeed **49** and Mizpah [*"watchtower"*], for he said, "the LORD watch between me and you, when we are absent one from another. **50** If you afflict my daughters, or if you take wives besides my daughters, no man is with us; behold, God is witness between me and you." **51** Laban said to Jacob, "See this heap, and see the pillar, which I have set between me and you. **52** May this heap be a witness, and the pillar be a witness, that I will not pass over this heap to you, and that you will not pass over this heap and this pillar to me, for harm. **53** The God of Abraham, and the God of Nahor, the God of their father, judge between us." Then Jacob swore by the fear of his father, Isaac. **54** Jacob offered a sacrifice in the mountain, and called his relatives to eat bread. They ate bread, and stayed all night in the mountain. **55** Early in the morning, Laban rose up, and kissed his sons and his daughters, and blessed them. Laban departed and returned to his place.

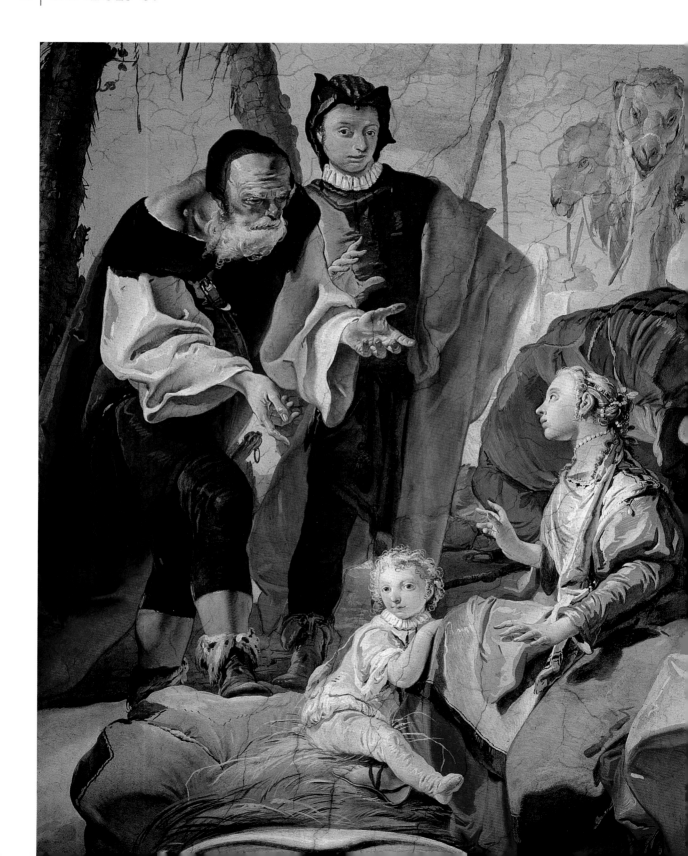

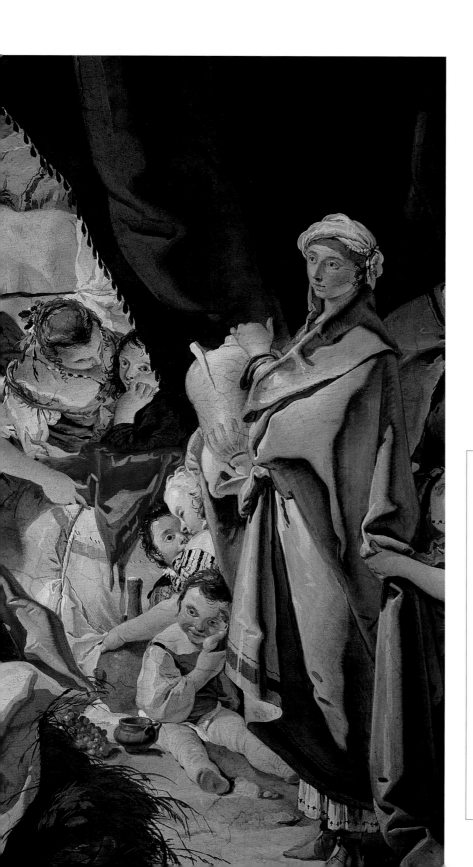

Rachel Hiding the Idols

Giambattista Tiepolo
1726–29

Feeling mistreated by his father-in-law Laban, Jacob decided to return to Canaan secretly with his family, but Laban found out and pursued them. Unbeknown to Jacob, his wife Rachel had stolen her father's household idols— these probably functioned as symbols of inheritance rights. On the far left of this fresco an angry Laban stands in the opening of the tent next to Jacob, demanding the return of his idols. Rachel, sitting on the camel saddle in which she has hidden the idols, is shown telling her father that she is too indisposed to stand up while he searches the tent.

CHAPTERS 32–33

A worried Jacob sends messengers bearing gifts to his brother Esau—whom he had tricked out of receiving the blessing of the firstborn from their father Isaac—to let Esau know that he is coming. Jacob spends a night wrestling with an unnamed man (an angel of God), who gives Jacob another name: Israel (meaning "he struggles with God"). When Jacob finally meets up with Esau, he discovers that Esau has forgiven him. Jacob and his family then settle down near the city of Shechem.

CHAPTER 32

Jacob went on his way, and the angels of God met him. **2** When he saw them, Jacob said, "This is God's army." He called the name of that place Mahanaim. **3** Jacob sent messengers in front of him to Esau, his brother, to the land of Seir, the field of Edom. **4** He commanded them, saying, "This is what you shall tell my lord, Esau: 'This is what your servant, Jacob, says. I have lived as a foreigner with Laban, and stayed until now. **5** I have cattle, donkeys, flocks, male servants, and female servants. I have sent to tell my lord, that I may find favor in your sight.'" **6** The messengers returned to Jacob, saying, "We came to your brother Esau. Not only that, but he comes to meet you, and four hundred men with him." **7** Then Jacob was greatly afraid and was distressed. He divided the people who were with him, and the flocks, and the herds, and the camels, into two companies; **8** and he said, "If Esau comes to the one company, and strikes it, then the company which is left will escape." **9** Jacob said, "God of my father Abraham, and God of my father Isaac, the LORD, who said to me, 'Return to your country, and to your relatives, and I will do you good,' **10** I am not worthy of the least of all the loving kindnesses, and of all the truth, which you have shown to your servant; for with just my staff I crossed over this Jordan; and now I have become two companies. **11** Please deliver me from the hand of my brother, from the hand of Esau: for I fear him, lest he come and strike me, and the mothers with the children. **12** You said, 'I will surely do you good, and make your offspring as the sand of the sea, which can't be counted because there are so many.'"

13 He stayed there that night, and took from that which he had with him, a present for Esau, his brother: **14** two hundred female goats and twenty male goats, two hundred ewes and twenty rams, **15** thirty milk camels and their colts, forty cows, ten bulls, twenty female donkeys and ten foals. **16** He delivered them into the hands of his servants, every herd by itself, and said to his servants, "Pass over before me, and put a space between herd and herd." **17** He commanded the foremost, saying, "When Esau, my brother, meets you, and asks you, saying, 'Whose are you? Where are you going? Whose are these before you?' **18** Then you shall say, 'They are your servant, Jacob's. It is a present sent to my lord, Esau. Behold, he also is behind us.'" **19** He commanded also the second, and the third, and all that followed the herds, saying, "This is how you shall speak to Esau, when you find him. **20** You shall say, 'Not only that, but behold, your servant, Jacob, is behind us.'" For, he said, "I will appease him with the present that goes before me, and afterward I will see his face. Perhaps he will accept me."

21 So the present passed over before him, and he himself stayed that night in the camp.

22 He rose up that night, and took his two wives, and his two servants, and his eleven sons, and crossed over the ford of the Jabbok. **23** He took them, and sent them over the stream, and sent over that which he had. **24** Jacob was left alone, and wrestled with a man there until the breaking of the day. **25** When he saw that he didn't prevail against him, he touched the hollow of his thigh, and the hollow of Jacob's thigh was strained, as he wrestled. **26** The man said, "Let me go, for the day breaks."

Jacob said, "I won't let you go, unless you bless me."

27 He said to him, "What is your name?"

He said, "Jacob." **28** He said, "Your name will no longer be called Jacob, but Israel; for you have fought with God and with men, and have prevailed."

29 Jacob asked him, "Please tell me your name."

He said, "Why is it that you ask what my name is?" He blessed him there.

30 Jacob called the name of the place Peniel ["*face of God*"]: for, he said, "I have seen God face to face, and my life is preserved." **31** The sun rose on him as he passed over Peniel, and he limped because of his thigh. **32** Therefore the children of Israel don't eat the sinew of the hip, which is on the hollow of the thigh, to this day, because he touched the hollow of Jacob's thigh in the sinew of the hip.

CHAPTER 33

Jacob lifted up his eyes, and looked, and, behold, Esau was coming, and with him four hundred men. He divided the children between Leah, Rachel, and the two servants. **2** He put the servants and their children in front, Leah and her children after, and Rachel and Joseph at the rear. **3** He himself passed over in front of them, and bowed himself to the ground seven times, until he came near to his brother.

4 Esau ran to meet him, embraced him, fell on his neck, kissed him, and they wept. **5** He lifted up his eyes, and saw the women and the children; and said, "Who are these with you?"

He said, "The children whom God has graciously given your servant." **6** Then the servants came near with their children, and they bowed themselves. **7** Leah also and her children came near, and bowed themselves. After them, Joseph came near with Rachel, and they bowed themselves.

8 Esau said, "What do you mean by all this company which I met?"

Jacob said, "To find favor in the sight of my lord."

9 Esau said, "I have enough, my brother; let that which you have be yours."

10 Jacob said, "Please, no, if I have now found favor in your sight, then receive my present at my hand, because I have seen your face, as one sees the face of God, and you were pleased with me. **11** Please take the gift that I brought to you, because God has dealt graciously with me, and because I have enough." He urged him, and he took it.

12 Esau said, "Let us take our journey, and let us go, and I will go before you."

13 Jacob said to him, "My lord knows that the children are tender, and that the flocks and herds with me have their young, and if they overdrive them one day, all the flocks will die. **14** Please let my lord pass over before his servant, and I will lead on gently, according to the pace of the livestock that are before me and according to the pace of the children, until I come to my lord in Seir."

15 Esau said, "Let me now leave with you some of the folk who are with me."

He said, "Why? Let me find favor in the sight of my lord."

16 So Esau returned that day on his way to Seir. **17** Jacob traveled to Succoth, built himself a house, and made shelters for his livestock. Therefore the name of the place is called Succoth ["*shelters*"].

18 Jacob came in peace to the city of Shechem, which is in the land of Canaan, when he came from Paddan Aram; and encamped before the city. **19** He bought the parcel of ground where he had spread his tent, at the hand of the children of Hamor, Shechem's father, for one hundred pieces of money. **20** He erected an altar there, and called it El Elohe Israel ["*God, the God of Israel*" or "*the God of Israel is mighty*"].

Jacob Wrestling with the Angel

Eugène Delacroix
1855–61

This detail from a fresco in the Church of Saint-Sulpice in Paris, France, shows Jacob wrestling with an angel (described in the biblical text as a man who refused to give his name). The angel is shown touching Jacob's thigh, which caused Jacob to limp and gave rise to Jewish dietary laws regarding eating meat from the hip area.

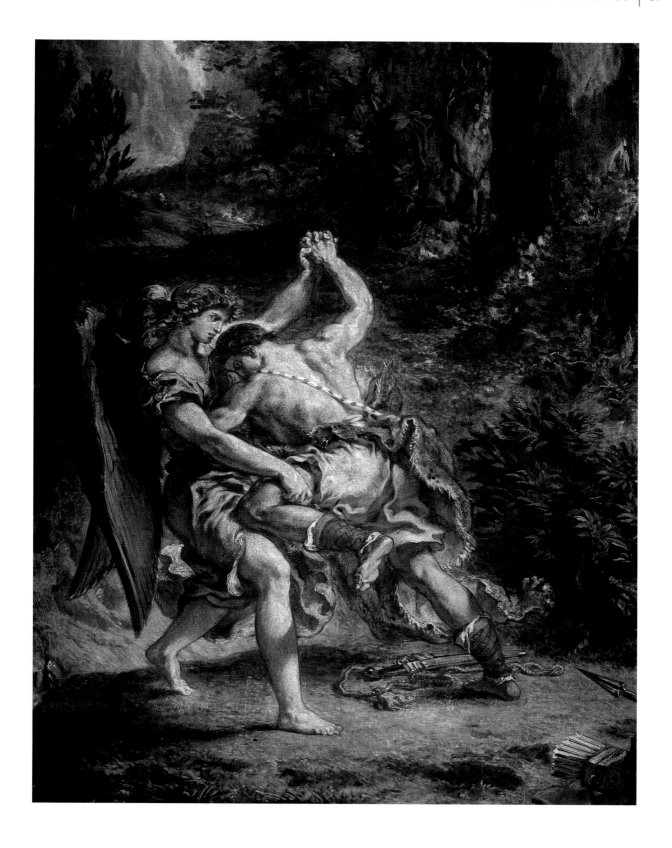

CHAPTERS 34–36

The prince of Shechem kidnaps Jacob's daughter Dinah and rapes her. Jacob's sons Simeon and Levi rescue their sister and kill all of the men in Shechem in retaliation. Jacob's wife Rachel dies giving birth to her second son, Benjamin, and is buried in Bethlehem. Altogether, Jacob has twelve sons. Jacob's father Isaac dies at the age of 180. A genealogy lists the descendants of Jacob's brother Esau. Esau's alternative name is Edom, and the nation formed of his descendants, the Edomites, has many kings.

CHAPTER 34

Dinah, the daughter of Leah, whom she bore to Jacob, went out to see the daughters of the land. **2** Shechem the son of Hamor the Hivite, the prince of the land, saw her. He took her, lay with her, and humbled her. **3** His soul joined to Dinah, the daughter of Jacob, and he loved the young lady, and spoke kindly to the young lady. **4** Shechem spoke to his father, Hamor, saying, "Get me this young lady as a wife."

5 Now Jacob heard that he had defiled Dinah, his daughter; and his sons were with his livestock in the field. Jacob held his peace until they came. **6** Hamor the father of Shechem went out to Jacob to talk with him. **7** The sons of Jacob came in from the field when they heard it. The men were grieved, and they were very angry, because he had done folly in Israel in lying with Jacob's daughter; a thing ought not to be done. **8** Hamor talked with them, saying, "The soul of my son, Shechem, longs for your daughter. Please give her to him as a wife. **9** Make marriages with us. Give your daughters to us, and take our daughters for yourselves. **10** You shall dwell with us, and the land will be before you. Live and trade in it, and get possessions in it."

11 Shechem said to her father and to her brothers, "Let me find favor in your eyes, and whatever you will tell me I will give. **12** Ask me a great amount for a dowry, and I will give whatever you ask of me, but give me the young lady as a wife."

13 The sons of Jacob answered Shechem and Hamor his father with deceit, and spoke, because he had defiled Dinah their sister, **14** and said to them, "We can't do this thing, to give our sister to one who is uncircumcised; for that is a reproach to us. **15** Only on this condition will we consent to you. If you will be as we are, that every male of you be circumcised; **16** then will we give our daughters to you, and we will take your daughters to us, and we will dwell with you, and we will become one people. **17** But if you will not listen to us, to be circumcised, then we will take our sister, and we will be gone."

18 Their words pleased Hamor and Shechem, Hamor's son. **19** The young man didn't wait to do this thing, because he had delight in Jacob's daughter, and he was honored above all the house of his father. **20** Hamor and Shechem, his son, came to the gate of their city, and talked with the men of their city, saying, **21** "These men are peaceful with us. Therefore let them live in the land and trade in it. For behold, the land is large enough for them. Let us take their daughters to us for wives, and let us give them our daughters. **22** Only on this condition will the men consent to us to live with us, to become one people, if every male among us is circumcised, as they are circumcised. **23** Won't their livestock and their possessions and all their animals be ours? Only let us give our consent to them, and they will dwell with us."

24 All who went out of the gate of his city listened to Hamor, and to Shechem his son; and every male was circumcised, all who went out of the gate of his city. **25** On the third day, when they were sore, two of Jacob's sons, Simeon and Levi, Dinah's brothers, each took his sword, came upon the unsuspecting city, and killed all the males. **26** They killed Hamor and Shechem, his son, with the edge of the sword, and took Dinah out of Shechem's house, and went away. **27** Jacob's sons came

Two of Jacob's sons, Simeon and Levi, Dinah's brothers, each took his sword, came upon the unsuspecting city, and killed all the males. They killed Hamor and Shechem, his son, with the edge of the sword, and took Dinah out of Shechem's house, and went away. Jacob's sons came on the dead, and plundered the city, because they had defiled their sister.

Genesis 34:25—27

on the dead, and plundered the city, because they had defiled their sister. **28** They took their flocks, their herds, their donkeys, that which was in the city, that which was in the field, **29** and all their wealth. They took captive all their little ones and their wives, and took as plunder everything that was in the house. **30** Jacob said to Simeon and Levi, "You have troubled me, to make me odious to the inhabitants of the land, among the Canaanites and the Perizzites. I am few in number. They will gather themselves together against me and strike me, and I will be destroyed, I and my house."

31 They said, "Should he deal with our sister as with a prostitute?"

CHAPTER 35

God said to Jacob, "Arise, go up to Bethel, and live there. Make there an altar to God, who appeared to you when you fled from the face of Esau your brother."

2 Then Jacob said to his household, and to all who were with him, "Put away the foreign gods that are among you, purify yourselves, change your garments. **3** Let us arise, and go up to Bethel. I will make there an altar to God, who answered me in the day of my distress, and was with me on the way which I went."

4 They gave to Jacob all the foreign gods which were in their hands, and the rings which were in their ears; and Jacob hid them under the oak which was by Shechem. **5** They traveled, and a terror of God was on the cities that were around them, and they didn't pursue the sons of Jacob. **6** So Jacob came to Luz (that is, Bethel), which is in the land of Canaan, he and all the people who were with him. **7** He built an altar there, and called the place El Bethel [*"God of Bethel"*]; because there God was revealed to him, when he fled from the face of his brother. **8** Deborah, Rebekah's nurse, died, and she was buried below Bethel under the oak; and its name was called Allon Bacuth [*"oak of weeping"*].

9 God appeared to Jacob again, when he came from Paddan Aram, and blessed him. **10** God said to him, "Your name is Jacob. Your name shall not be Jacob any more, but your name will be Israel." He named him Israel. **11** God said to him, "I am God Almighty. Be fruitful and multiply. A nation and a company of nations will be from you, and kings will come out of your body. **12** The land which I gave to Abraham and Isaac, I will give it to you, and to your offspring after you will I give the land."

13 God went up from him in the place where he spoke with him. **14** Jacob set up a pillar in the place where he spoke with him, a pillar of stone. He poured out a drink offering on it, and poured oil on it. **15** Jacob

The Massacre of the Shechemites

French School

15TH CENTURY

This illumination is from a copy of the *Bible Historiale*, a medieval French translation of the Bible with added commentary, produced for Jean, Duke of Berry. Dinah, the daughter of Jacob and Leah, stands on the right trying to turn away from Shechem, a prince who kidnapped and raped her. In retaliation, Dinah's brothers Simeon and Levi killed all the men of Shechem's city as well as Shechem himself.

> *They traveled from Bethel. There was still some distance to come to Ephrath, and Rachel travailed. She had hard labor. When she was in hard labor, the midwife said to her, "Don't be afraid, for now you will have another son." As her soul was departing (for she died), she named him Benoni, but his father named him Benjamin. Rachel died, and was buried on the way to Ephrath (also called Bethlehem).*
>
> Genesis 35:16–19

called the name of the place where God spoke with him Bethel.

16 They traveled from Bethel. There was still some distance to come to Ephrath, and Rachel travailed. She had hard labor. **17** When she was in hard labor, the midwife said to her, "Don't be afraid, for now you will have another son."

18 As her soul was departing (for she died), she named him Benoni [*"son of my trouble"*], but his father named him Benjamin [*"son of my right hand"*]. **19** Rachel died, and was buried on the way to Ephrath (also called Bethlehem). **20** Jacob set up a pillar on her grave. The pillar of Rachel's grave is there to this day. **21** Israel traveled, and spread his tent beyond the tower of Eder. **22** While Israel lived in that land, Reuben went and lay with Bilhah, his father's concubine, and Israel heard of it.

Now the sons of Jacob were twelve. **23** The sons of Leah: Reuben (Jacob's firstborn), Simeon, Levi, Judah, Issachar, and Zebulun. **24** The sons of Rachel: Joseph and Benjamin. **25** The sons of Bilhah (Rachel's servant): Dan and Naphtali. **26** The sons of Zilpah (Leah's servant): Gad and Asher. These are the sons of Jacob, who were born to him in Paddan Aram. **27** Jacob came to Isaac his father, to Mamre, to Kiriath Arba (which is Hebron), where Abraham and Isaac lived as foreigners.

28 The days of Isaac were one hundred eighty years. **29** Isaac gave up the spirit, and died, and was gathered to his people, old and full of days. Esau and Jacob, his sons, buried him.

CHAPTER 36

Now this is the history of the generations of Esau (that is, Edom). **2** Esau took his wives from the daughters of Canaan: Adah the daughter of Elon, the Hittite; and Oholibamah the daughter of Anah, the daughter of Zibeon, the Hivite; **3** and Basemath, Ishmael's daughter, sister of Nebaioth. **4** Adah bore to Esau Eliphaz. Basemath bore Reuel. **5** Oholibamah bore Jeush, Jalam, and Korah. These are the sons of Esau, who were born to him in the land of Canaan. **6** Esau took his wives, his sons, his

daughters, and all the members of his household, with his livestock, all his animals, and all his possessions, which he had gathered in the land of Canaan, and went into a land away from his brother Jacob. **7** For their substance was too great for them to dwell together, and the land of their travels could not bear them because of their livestock. **8** Esau lived in the hill country of Seir. Esau is Edom.

9 This is the history of the generations of Esau the father of the Edomites in the hill country of Seir: **10** these are the names of Esau's sons: Eliphaz, the son of Adah, the wife of Esau; and Reuel, the son of Basemath, the wife of Esau. **11** The sons of Eliphaz were Teman, Omar, Zepho, and Gatam, and Kenaz. **12** Timna was concubine to Eliphaz, Esau's son; and she bore to Eliphaz Amalek. These are the sons of Adah, Esau's wife. **13** These are the sons of Reuel: Nahath, Zerah, Shammah, and Mizzah. These were the sons of Basemath, Esau's wife. **14** These were the sons of Oholibamah, the daughter of Anah, the daughter of Zibeon, Esau's wife: she bore to Esau Jeush, Jalam, and Korah.

15 These are the chiefs of the sons of Esau: the sons of Eliphaz the firstborn of Esau: chief Teman, chief Omar, chief Zepho, chief Kenaz, **16** chief Korah, chief Gatam, chief Amalek: these are the chiefs who came of Eliphaz in the land of Edom; these are the sons of Adah. **17** These are the sons of Reuel, Esau's son: chief Nahath, chief Zerah, chief Shammah, chief Mizzah: these are the chiefs who came of Reuel in the land of Edom; these are the sons of Basemath, Esau's wife. **18** These are the sons of Oholibamah, Esau's wife: chief Jeush, chief Jalam, chief Korah: these are the chiefs who came of Oholibamah the daughter of Anah, Esau's wife. **19** These are the sons of Esau (that is, Edom), and these are their chiefs.

20 These are the sons of Seir the Horite, the inhabitants of the land: Lotan, Shobal, Zibeon, Anah, **21** Dishon, Ezer, and Dishan. These are the chiefs who came of the Horites, the children of Seir in the land of Edom. **22** The children of Lotan were Hori and Heman. Lotan's sister was Timna. **23** These are the children of Shobal: Alvan, Manahath, Ebal, Shepho, and Onam. **24** These are the children of Zibeon: Aiah and Anah. This is Anah who found the hot springs in the wilderness, as he fed the donkeys of Zibeon his father. **25** These are the children of Anah: Dishon and Oholibamah, the daughter of Anah. **26** These are the children of Dishon: Hemdan, Eshban, Ithran, and Cheran. **27** These are the children of Ezer: Bilhan, Zaavan, and Akan. **28** These are the children of Dishan: Uz and Aran. **29** These are the chiefs who came of the Horites: chief Lotan, chief Shobal, chief Zibeon, chief Anah, **30** chief Dishon, chief Ezer, and chief Dishan: these are the chiefs who came of the Horites, according to their chiefs in the land of Seir.

31 These are the kings who reigned in the land of Edom, before any king reigned over the children of Israel. **32** Bela, the son of Beor, reigned in Edom. The name of his city was Dinhabah. **33** Bela died, and Jobab, the son of Zerah of Bozrah, reigned in his place. **34** Jobab died, and Husham of the land of the Temanites reigned in his place. **35** Husham died, and Hadad, the son of Bedad, who struck Midian in the field of Moab, reigned in his place. The name of his city was Avith. **36** Hadad died, and Samlah of Masrekah reigned in his place. **37** Samlah died, and Shaul of Rehoboth by the river, reigned in his place. **38** Shaul died, and Baal Hanan, the son of Achbor reigned in his place. **39** Baal Hanan the son of Achbor died, and Hadar reigned in his place. The name of his city was Pau. His wife's name was Mehetabel, the daughter of Matred, the daughter of Mezahab.

40 These are the names of the chiefs who came from Esau, according to their families, after their places, and by their names: chief Timna, chief Alvah, chief Jetheth, **41** chief Oholibamah, chief Elah, chief Pinon, **42** chief Kenaz, chief Teman, chief Mibzar, **43** chief Magdiel, and chief Iram. These are the chiefs of Edom, according to their habitations in the land of their possession. This is Esau, the father of the Edomites.

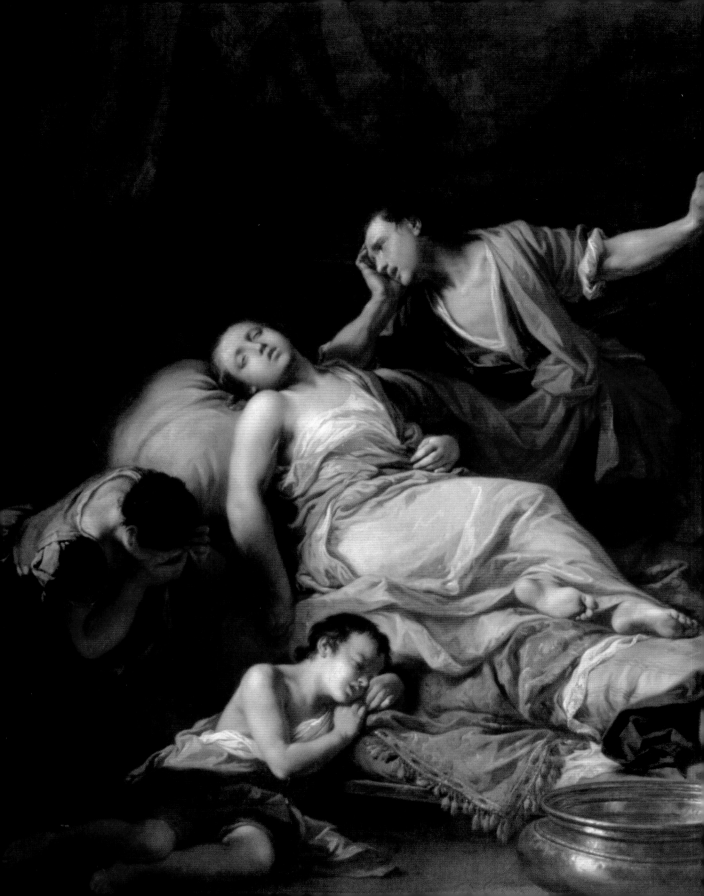

The Death of Rachel

Giambettino Cignaroli
1770

During a journey to Ephrath (also known as Bethlehem), Jacob's wife Rachel went into labor and died giving birth to her second son, Benjamin. In this painting a bereaved Jacob leans over the body of his dead wife. At the foot of the bed, a servant holds the newborn baby. The boy in the left foreground may be Rachel's firstborn son, Joseph.

CHAPTERS 37–40

Jealous at Jacob's favoritism of Joseph, Joseph's brothers sell him into slavery in Egypt and pretend that he has been killed. Two of Judah's sons marry Tamar, then die. When Judah refuses to let another son marry her, Tamar disguises herself, sleeps with Judah, and has twins. In Egypt, Pharaoh's wife tries to seduce Joseph. When he rejects her, she accuses him of attempted rape and Pharaoh imprisons him. In prison, Joseph interprets the dreams of Pharaoh's cup bearer and baker—the former will return to his position; the other will be executed.

CHAPTER 37

Jacob lived in the land of his father's travels, in the land of Canaan. **2** This is the history of the generations of Jacob. Joseph, being seventeen years old, was feeding the flock with his brothers. He was a boy with the sons of Bilhah and Zilpah, his father's wives. Joseph brought an evil report of them to their father. **3** Now Israel loved Joseph more than all his children, because he was the son of his old age, and he made him a coat of many colors. **4** His brothers saw that their father loved him more than all his brothers, and they hated him, and could not speak peaceably to him.

5 Joseph dreamed a dream, and he told it to his brothers, and they hated him all the more. **6** He said to them, "Please hear this dream which I have dreamed: **7** for behold, we were binding sheaves in the field, and behold, my sheaf arose and also stood upright; and behold, your sheaves came around, and bowed down to my sheaf."

8 His brothers said to him, "Will you indeed reign over us? Or will you indeed have dominion over us?" They hated him all the more for his dreams and for his words. **9** He dreamed yet another dream, and told it to his brothers, and said, "Behold, I have dreamed yet another dream: and behold, the sun and the moon and eleven stars bowed down to me." **10** He told it to his father and to his brothers. His father rebuked him, and said to him, "What is this dream that you have dreamed? Will I and your mother and your brothers indeed come to bow ourselves down to you to the earth?" **11** His brothers envied him, but his father kept this saying in mind.

12 His brothers went to feed their father's flock in Shechem. **13** Israel said to Joseph, "Aren't your brothers feeding the flock in Shechem? Come, and I will send you to them." He said to him, "Here I am."

14 He said to him, "Go now, see whether it is well with your brothers, and well with the flock; and bring me word again." So he sent him out of the valley of Hebron, and he came to Shechem. **15** A certain man found him, and behold, he was wandering in the field. The man asked him, "What are you looking for?"

16 He said, "I am looking for my brothers. Tell me, please, where they are feeding the flock."

17 The man said, "They have left here, for I heard them say, 'Let us go to Dothan.'"

Joseph went after his brothers, and found them in Dothan. **18** They saw him afar off, and before he came near to them, they conspired against him to kill him. **19** They said to one another, "Behold, this dreamer comes. **20** Come now therefore, and let's kill him, and cast him into one of the pits, and we will say, 'An evil animal has devoured him.' We will see what will become of his dreams."

21 Reuben heard it, and delivered him out of their hand, and said, "Let's not take his life." **22** Reuben said to them, "Shed no blood. Throw him into this pit that is in the wilderness, but lay no hand on him"—that he might deliver him out of their hand, to restore him to his father. **23** When Joseph came to his brothers, they stripped Joseph of his coat, the coat of many colors that was on him; **24** and they took him, and threw him into the pit. The pit was empty. There was no water in it.

25 They sat down to eat bread, and they lifted up their eyes and looked, and saw a caravan of Ishmaelites was coming from

Gilead, with their camels bearing spices and balm and myrrh, going to carry it down to Egypt. **26** Judah said to his brothers, "What profit is it if we kill our brother and conceal his blood? **27** Come, and let's sell him to the Ishmaelites, and not let our hand be on him; for he is our brother, our flesh." His brothers listened to him. **28** Midianites who were merchants passed by, and they drew and lifted up Joseph out of the pit, and sold Joseph to the Ishmaelites for twenty pieces of silver. They brought Joseph into Egypt.

29 Reuben returned to the pit; and saw that Joseph was not in the pit; and he tore his clothes. **30** He returned to his brothers, and said, "The child is no more; and I, where will I go?" **31** They took Joseph's coat, and killed a male goat, and dipped the coat in the blood. **32** They took the coat of many colors, and they brought it to their father, and said, "We have found this. Examine it, now, whether it is your son's coat or not."

33 He recognized it, and said, "It is my son's coat. An evil animal has devoured him. Joseph is without doubt torn in pieces." **34** Jacob tore his clothes, and put sackcloth on his waist, and mourned for his son many days. **35** All his sons and all his daughters rose up to comfort him, but he refused to be comforted. He said, "For I will go down to Sheol [*the place of the dead*] to my son mourning." His father wept for him. **36** The Midianites sold him into Egypt to Potiphar, an officer of Pharaoh's, the captain of the guard.

Joseph Sold into Slavery

Raphael
1517–19

This fresco is part of a series of 52 biblical scenes, known as the *Raphael Bible*, that decorate the Raphael Loggia (long, thin gallery) in the Vatican Palace in Rome, Italy. It shows Joseph's jealous brothers negotiating a price for him with a group of passing traders, who then sell Joseph into slavery in Egypt. The young Joseph is held in place by his brother Judah beside the open mouth of the pit (or well) where his brothers had imprisoned him.

CHAPTER 38

At that time, Judah went down from his brothers, and visited a certain Adullamite, whose name was Hirah. **2** Judah saw there a daughter of a certain Canaanite whose name was Shua. He took her, and went in to her. **3** She conceived, and bore a son; and he named him Er. **4** She conceived again, and bore a son; and she named him Onan. **5** She yet again bore a son, and named him Shelah: and he was at Chezib, when she bore him. **6** Judah took a wife for Er, his firstborn, and her name was Tamar. **7** Er, Judah's firstborn, was wicked in the LORD's sight. The LORD killed him. **8** Judah said to Onan, "Go in to your brother's wife, and perform the duty of a husband's brother to her, and raise up offspring for your brother." **9** Onan knew that the offspring would not be his; and when he went in to his brother's wife, he spilled his semen on the ground, lest he should give offspring to his brother. **10** The thing which he did was evil in the LORD's sight, and he killed him also. **11** Then Judah said to Tamar, his daughter-in-law, "Remain a widow in your father's house, until Shelah, my son, is grown up"; for he said, "Lest he also die, like his brothers." Tamar went and lived in her father's house.

12 After many days, Shua's daughter, the wife of Judah, died. Judah was comforted, and went up to his sheep shearers to Timnah, he and his friend Hirah, the Adullamite. **13** Tamar was told, "Behold, your father-in-law is going up to Timnah to shear his sheep." **14** She took off the garments of her widowhood, and covered herself with her veil, and wrapped herself, and sat in the gate of Enaim, which is by the way to Timnah; for she saw that Shelah was grown up, and she was not given to him as a wife. **15** When Judah saw her, he thought that she was a prostitute, for she had covered her face. **16** He turned to her by the way, and said, "Please come, let me come in to you," for he did not know that she was his daughter-in-law.

She said, "What will you give me, that you may come in to me?"

17 He said, "I will send you a young goat from the flock."

She said, "Will you give me a pledge, until you send it?"

18 He said, "What pledge will I give you?"

She said, "Your signet and your cord, and your staff that is in your hand."

He gave them to her, and came in to her, and she conceived by him. **19** She arose, and went away, and put off her veil from her, and put on the garments of her widowhood. **20** Judah sent the young goat by the hand of his friend, the Adullamite, to receive the pledge from the woman's hand, but he didn't find her. **21** Then he asked the men of her place, saying, "Where is the prostitute, that was at Enaim by the road?"

They said, "There has been no prostitute here."

22 He returned to Judah, and said, "I haven't found her; and also the men of the place said, 'There has been no prostitute here.'" **23** Judah said, "Let her keep it, lest we be shamed. Behold, I sent this young goat, and you haven't found her."

24 About three months later, Judah was told, "Tamar, your daughter-in-law, has played the prostitute. Moreover, behold, she is with child by prostitution."

Judah said, "Bring her out, and let her be burned." **25** When she was brought out, she sent to her father-in-law, saying, "By the man, whose these are, I am with child." She also said, "Please discern whose are these—the signet, and the cords, and the staff."

26 Judah acknowledged them, and said, "She is more righteous than I, because I didn't give her to Shelah, my son."

He knew her again no more. **27** In the time of her travail, behold, twins were in her womb. **28** When she travailed, one put out a hand, and the midwife took and tied a scarlet thread on his hand, saying, "This came out first." **29** As he drew back his hand, behold, his brother came out, and she said, "Why have you made a breach for yourself?" Therefore his name was called Perez [*"breaking out"*]. **30** Afterward his brother came out, that had the scarlet thread on his hand, and his name was called Zerah [*"scarlet" or "brightness"*].

CHAPTER 39

Joseph was brought down to Egypt. Potiphar, an officer of Pharaoh's, the captain of the guard, an Egyptian, bought him from the hand of the Ishmaelites that had brought him down there. **2** The LORD was with Joseph, and he was a

prosperous man. He was in the house of his master the Egyptian. ³ His master saw that the LORD was with him, and that the LORD made all that he did prosper in his hand. ⁴ Joseph found favor in his sight. He ministered to him, and he made him overseer over his house, and all that he had he put into his hand. ⁵ From the time that he made him overseer in his house, and over all that he had, the LORD blessed the Egyptian's house for Joseph's sake. The LORD's blessing was on all that he had, in the house and in the field. ⁶ He left all that he had in Joseph's hand. He didn't concern himself with anything, except for the food which he ate.

Joseph was well-built and handsome. ⁷ After these things, his master's wife set her eyes on Joseph; and she said, "Lie with me."

⁸ But he refused, and said to his master's wife, "Behold, my master doesn't know what is with me in the house, and he has put all that he has into my hand. ⁹ No one is greater in this house than I am, and he has not kept back anything from me but you, because you are his wife. How then can I do this great wickedness, and sin against God?"

¹⁰ As she spoke to Joseph day by day, he did not listen to her, to lie by her, or to be with her. ¹¹ About this time, he went into the house to do his work, and there were none of the men of the house inside. ¹² She caught him by his garment, saying, "Lie with me!"

He left his garment in her hand, and ran outside. ¹³ When she saw that he had left his garment in her hand, and had run outside, ¹⁴ she called to the men of her house, and spoke to them, saying, "Behold, he has brought in a Hebrew to us to mock us. He came in to me to lie with me, and I cried with a loud voice. ¹⁵ When he heard that I lifted up my voice and cried, he left his garment by me, and ran outside." ¹⁶ She laid up his garment by her, until his master came home. ¹⁷ She spoke to him according to these words, saying, "The Hebrew servant, whom you have brought to us, came in to me to mock me, ¹⁸ and as I lifted up my voice and cried, he left his garment by me, and ran outside."

¹⁹ When his master heard the words of his wife, which she spoke to him, saying, "This is what your servant did to me," his wrath was kindled. ²⁰ Joseph's master took him, and put him into the prison, the place where the king's prisoners were bound, and he was there

in custody. ²¹ But the LORD was with Joseph, and showed kindness to him, and gave him favor in the sight of the keeper of the prison. ²² The keeper of the prison committed to Joseph's hand all the prisoners who were in the prison. Whatever they did there, he was responsible for it. ²³ The keeper of the prison did not look after anything that was under his hand, because the LORD was with him; and that which he did, the LORD made it prosper.

CHAPTER 40

After these things, the butler of the king of Egypt and his baker offended their lord, the king of Egypt. ² Pharaoh was angry with his two officers, the chief cup bearer and the chief baker. ³ He put them in custody in the house of the captain of the guard, into the prison, the place where Joseph was bound. ⁴ The captain of the guard assigned them to Joseph, and he took care of them. They stayed in prison many days. ⁵ They both dreamed a dream, each man his dream, in one night, each man according to the interpretation of his dream, the cup bearer and the baker of the king of Egypt, who were bound in the prison. ⁶ Joseph came in to them in the morning, and saw them, and saw that they were sad. ⁷ He asked Pharaoh's officers who were with him in custody in his master's house, saying, "Why do you look so sad today?"

⁸ They said to him, "We have dreamed a dream, and there is no one who can interpret it."

Joseph said to them, "Don't interpretations belong to God? Please tell it to me."

⁹ The chief cup bearer told his dream to Joseph, and said to him, "In my dream, behold, a vine was in front of me, ¹⁰ and in the vine were three branches. It was as though it budded, it blossomed, and its clusters produced ripe grapes. ¹¹ Pharaoh's cup was in my hand; and I took the grapes, and pressed them into Pharaoh's cup, and I gave the cup into Pharaoh's hand."

¹² Joseph said to him, "This is its interpretation: the three branches are three days. ¹³ Within three more days, Pharaoh will lift up your head, and restore you to your office. You will give Pharaoh's cup into his

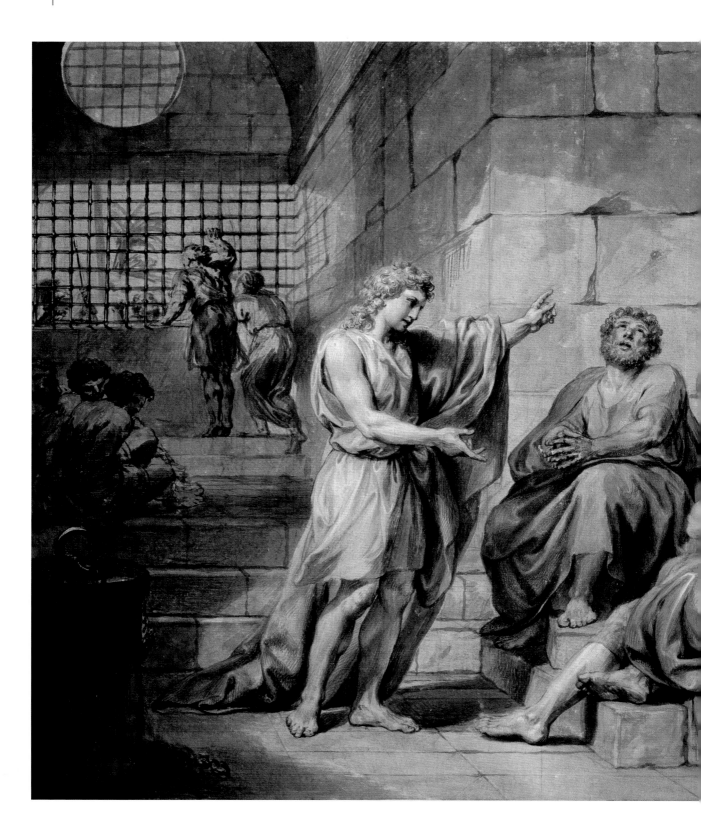

hand, the way you did when you were his cup bearer. **14** But remember me when it will be well with you, and please show kindness to me, and make mention of me to Pharaoh, and bring me out of this house. **15** For indeed, I was stolen away out of the land of the Hebrews, and here also have I done nothing that they should put me into the dungeon."

16 When the chief baker saw that the interpretation was good, he said to Joseph, "I also was in my dream, and behold, three baskets of white bread were on my head. **17** In the uppermost basket there were all kinds of baked food for Pharaoh, and the birds ate them out of the basket on my head."

18 Joseph answered, "This is its interpretation. The three baskets are three days. **19** Within three more days, Pharaoh will lift up your head from off you, and will hang you on a tree; and the birds will eat your flesh from off you." **20** On the third day, which was Pharaoh's birthday, he made a feast for all his servants, and he lifted up the head of the chief cup bearer and the head of the chief baker among his servants. **21** He restored the chief cup bearer to his position again, and he gave the cup into Pharaoh's hand; **22** but he hanged the chief baker, as Joseph had interpreted to them. **23** Yet the chief cup bearer didn't remember Joseph, but forgot him.

Joseph of Egypt in Prison

Anton Raphael Mengs
1755–56

When the Pharaoh's cup bearer and baker were imprisoned for offending their king, each of the two men had a disturbing dream. Here, their fellow prisoner Joseph stands before the men interpreting their dreams—the cup bearer would be restored to his former position; the baker (on the right, showing alarm) would be executed.

CHAPTERS 41—44

Joseph is summoned from prison to interpret the Pharaoh's dreams—there will be seven years of plenty followed by seven years of famine. The Pharaoh puts Joseph in charge of preparing for the famine. When Joseph's brothers go to buy grain in Egypt, Joseph imprisons his brother Simeon, promising to free him if they bring Benjamin to Egypt. When they do so, Joseph releases Simeon and gives a banquet. Joseph tells a servant to sneak a silver cup into Benjamin's bag, then accuses the brothers of theft. His brother Judah pleads to take Benjamin's punishment.

CHAPTER 41

At the end of two full years, Pharaoh dreamed: and behold, he stood by the river. **2** Behold, there came up out of the river seven cattle, sleek and fat, and they fed in the marsh grass. **3** Behold, seven other cattle came up after them out of the river, ugly and thin, and stood by the other cattle on the brink of the river. **4** The ugly and thin cattle ate up the seven sleek and fat cattle. So Pharaoh awoke. **5** He slept and dreamed a second time: and behold, seven heads of grain came up on one stalk, healthy and good. **6** Behold, seven heads of grain, thin and blasted with the east wind, sprung up after them. **7** The thin heads of grain swallowed up the seven healthy and full ears. Pharaoh awoke, and behold, it was a dream. **8** In the morning, his spirit was troubled, and he sent and called for all of Egypt's magicians and wise men. Pharaoh told them his dreams, but there was no one who could interpret them to Pharaoh.

9 Then the chief cup bearer spoke to Pharaoh, saying, "I remember my faults today. **10** Pharaoh was angry with his servants, and put me in custody in the house of the captain of the guard, me and the chief baker. **11** We dreamed a dream in one night, I and he. We dreamed each man according to the interpretation of his dream. **12** There was with us there a young man, a Hebrew, servant to the captain of the guard, and we told him, and he interpreted to us our dreams. To each man according to his dream he interpreted. **13** As he interpreted to us, so it was. He restored me to my office, and he hanged him."

14 Then Pharaoh sent and called Joseph, and they brought him hastily out of the dungeon. He shaved himself, changed his clothing, and came in to Pharaoh. **15** Pharaoh said to Joseph, "I have dreamed a dream, and there is no one who can interpret it. I have heard it said of you, that when you hear a dream you can interpret it."

16 Joseph answered Pharaoh, saying, "It isn't in me. God will give Pharaoh the answer he desires."

17 Pharaoh spoke to Joseph, "In my dream, behold, I stood on the brink of the river: **18** and behold, there came up out of the river seven cattle, fat and sleek. They fed in the marsh grass, **19** and behold, seven other cattle came up after them, poor and very ugly and thin, such as I never saw in all the land of Egypt for ugliness. **20** The thin and ugly cattle ate up the first seven fat cattle, **21** and when they had eaten them up, it couldn't be known that they had eaten them, but they were still ugly, as at the beginning. So I awoke. **22** I saw

OVERLEAF: Joseph Interpreting Pharaoh's Dream

Reginald Arthur
1893–94

This painting shows Joseph, freshly shaved and clothed after being brought from prison, standing before Pharaoh and interpreting his dream. Joseph told Pharaoh that there would be seven years of plenty followed by seven years of famine. Because God had revealed the meaning of the dream to Joseph, Pharaoh put Joseph in charge of making preparations for the coming famine.

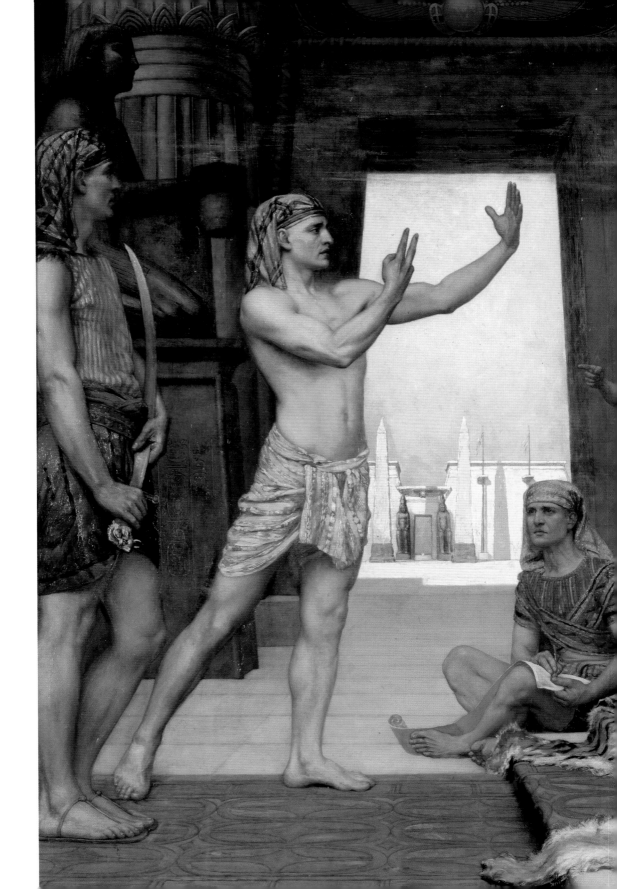

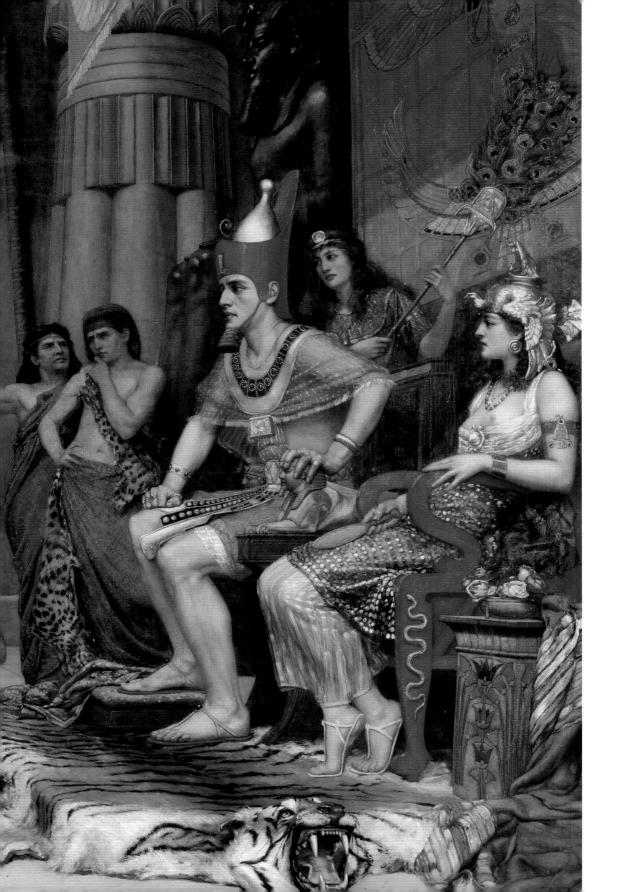

> *"What God is about to do he has shown to Pharaoh. Behold, there come seven years of great plenty throughout all the land of Egypt. There will arise after them seven years of famine, and all the plenty will be forgotten in the land of Egypt. The famine will consume the land, and the plenty will not be known in the land by reason of that famine which follows; for it will be very grievous."*
>
> Genesis 41:28–31

in my dream, and behold, seven heads of grain came up on one stalk, full and good: **23** and behold, seven heads of grain, withered, thin, and blasted with the east wind, sprung up after them. **24** The thin heads of grain swallowed up the seven good heads of grain. I told it to the magicians, but there was no one who could explain it to me."

25 Joseph said to Pharaoh, "The dream of Pharaoh is one. What God is about to do he has declared to Pharaoh. **26** The seven good cattle are seven years; and the seven good heads of grain are seven years. The dream is one. **27** The seven thin and ugly cattle that came up after them are seven years, and also the seven empty heads of grain blasted with the east wind; they will be seven years of famine. **28** That is the thing which I spoke to Pharaoh. What God is about to do he has shown to Pharaoh. **29** Behold, there come seven years of great plenty throughout all the land of Egypt. **30** There will arise after them seven years of famine, and all the plenty will be forgotten in the land of Egypt. The famine will consume the land, **31** and the plenty will not be known in the land by reason of that famine which follows; for it will be very grievous. **32** The dream was given to Pharaoh in two forms, because the matter has been firmly established by God, and God will shortly bring it to pass.

33 "Now therefore let Pharaoh look for a discreet and wise man, and set him over the land of Egypt. **34** Let Pharaoh do this, and let him appoint overseers over the land, and take up the fifth part of the land of Egypt's produce in the seven plenteous years. **35** Let them gather all the food of these good years that come, and lay up grain under the hand of Pharaoh for food in the cities, and let them keep it. **36** The food will be for a store to the land against the seven years of famine, which will be in the land of Egypt; that the land not perish through the famine."

37 The thing was good in the eyes of Pharaoh, and in the eyes of all his servants. **38** Pharaoh said to his servants, "Can we find such a one as this, a man in whom is the Spirit of God?" **39** Pharaoh said to Joseph, "Because God has shown you all of this, there is no one so discreet and wise as you. **40** You shall be over my house, and according to your word will all my people be ruled. Only in the throne I will be greater than you." **41** Pharaoh

said to Joseph, "Behold, I have set you over all the land of Egypt." **42** Pharaoh took off his signet ring from his hand, and put it on Joseph's hand, and arrayed him in robes of fine linen, and put a gold chain about his neck, **43** and he made him to ride in the second chariot which he had. They cried before him, "Bow the knee!" He set him over all the land of Egypt. **44** Pharaoh said to Joseph, "I am Pharaoh, and without you shall no man lift up his hand or his foot in all the land of Egypt." **45** Pharaoh called Joseph's name Zaphenath-Paneah; and he gave him Asenath, the daughter of Potiphera priest of On as a wife. Joseph went out over the land of Egypt.

46 Joseph was thirty years old when he stood before Pharaoh king of Egypt. Joseph went out from the presence of Pharaoh, and went throughout all the land of Egypt. **47** In the seven plenteous years the earth produced abundantly. **48** He gathered up all the food of the seven years which were in the land of Egypt, and laid up the food in the cities: the food of the field, which was around every city, he laid up in the same. **49** Joseph laid up grain as the sand of the sea, very much, until he stopped counting, for it was without number. **50** To Joseph were born two sons before the year of famine came, whom Asenath, the daughter of Potiphera priest of On, bore to him. **51** Joseph called the name of the firstborn Manasseh [*sounds like Hebrew for "forget"*], "For," he said, "God has made me forget all my toil, and all my father's house." **52** The name of the second, he called Ephraim [*sounds like Hebrew for "twice fruitful"*]: "For God has made me fruitful in the land of my affliction."

53 The seven years of plenty, that were in the land of Egypt, came to an end. **54** The seven years of famine began to come, just as Joseph had said. There was famine in all lands, but in all the land of Egypt there was bread. **55** When all the land of Egypt was famished, the people cried to Pharaoh for bread, and Pharaoh said to all the Egyptians, "Go to Joseph. What he says to you, do." **56** The famine was over all the surface of the earth. Joseph opened all the store houses, and sold to the Egyptians. The famine was severe in the land of Egypt. **57** All countries came into Egypt, to Joseph, to buy grain, because the famine was severe in all the earth.

CHAPTER 42

Now Jacob saw that there was grain in Egypt, and Jacob said to his sons, "Why do you look at one another?" **2** He said, "Behold, I have heard that there is grain in Egypt. Go down there, and buy for us from there, so that we may live, and not die." **3** Joseph's ten brothers went down to buy grain from Egypt. **4** But Jacob did not send Benjamin, Joseph's brother, with his brothers; for he said, "Lest perhaps harm happen to him." **5** The sons of Israel came to buy among those who came, for the famine was in the land of Canaan. **6** Joseph was the governor over the land. It was he who sold to all the people of the land. Joseph's brothers came, and bowed themselves down to him with their faces to the earth. **7** Joseph saw his brothers, and he recognized them, but acted like a stranger to them, and spoke roughly with them. He said to them, "Where did you come from?"

They said, "From the land of Canaan to buy food."

8 Joseph recognized his brothers, but they did not recognize him. **9** Joseph remembered the dreams which he dreamed about them, and said to them, "You are spies! You have come to see the nakedness of the land."

10 They said to him, "No, my lord, but your servants have come to buy food. **11** We are all one man's sons; we are honest men. Your servants are not spies."

12 He said to them, "No, but you have come to see the nakedness of the land!"

13 They said, "We, your servants, are twelve brothers, the sons of one man in the land of Canaan; and behold, the youngest is today with our father, and one is no more."

14 Joseph said to them, "It is like I told you, saying, 'You are spies!' **15** By this you shall be tested. By the life of Pharaoh, you shall not go out from here, unless your youngest brother comes here. **16** Send one of you, and let him get your brother, and you shall be bound, that your words may be tested, whether there is truth in you, or else by the life of Pharaoh surely you are spies." **17** He put them all together into custody for three days.

18 Joseph said to them the third day, "Do this, and live, for I fear God. **19** If you are honest men, then let one of your brothers be bound in your prison; but you go, carry grain

for the famine of your houses. **20** Bring your youngest brother to me; so will your words be verified, and you won't die."

They did so. **21** They said to one another, "We are certainly guilty concerning our brother, in that we saw the distress of his soul, when he begged us, and we wouldn't listen. Therefore this distress has come upon us." **22** Reuben answered them, saying, "Didn't I tell you, saying, 'Don't sin against the child,' and you wouldn't listen? Therefore also, behold, his blood is required." **23** They didn't know that Joseph understood them; for there was an interpreter between them. **24** He turned himself away from them, and wept. Then he returned to them, and spoke to them, and took Simeon from among them, and bound him before their eyes. **25** Then Joseph gave a command to fill their bags with grain, and to restore each man's money into his sack, and to give them food for the way. So it was done to them.

26 They loaded their donkeys with their grain, and departed from there. **27** As one of them opened his sack to give his donkey food in the lodging place, he saw his money. Behold, it was in the mouth of his sack. **28** He said to his brothers, "My money is restored! Behold, it is in my sack!" Their hearts failed them, and they turned trembling to one another, saying, "What is this that God has done to us?" **29** They came to Jacob their father, to the land of Canaan, and told him all that had happened to them, saying, **30** "The man, the lord of the land, spoke roughly with us, and took us for spies of the country. **31** We said to him, 'We are honest men. We are no spies. **32** We are twelve brothers, sons of our father; one is no more, and the youngest is today with our father in the land of Canaan.' **33** The man, the lord of the land, said to us, 'By this I will know that you are honest men: leave one of your brothers with me, and take grain for the famine of your houses, and go your way. **34** Bring your youngest brother to me. Then I will know that you are not spies, but that you are honest men. So I will deliver your brother to you, and you shall trade in the land.'"

35 As they emptied their sacks, behold, each man's bundle of money was in his sack. When they and their father saw their bundles of money, they were afraid. **36** Jacob, their father, said to them, "You have bereaved me of my children! Joseph is no more, Simeon is no more, and you want to take Benjamin away. All these things are against me."

37 Reuben spoke to his father, saying, "Kill my two sons, if I don't bring him to you. Entrust him to my care, and I will bring him to you again."

38 He said, "My son shall not go down with you; for his brother is dead, and he only is left. If harm happens to him along the way in which you go, then you will bring down my gray hairs with sorrow to Sheol [*the place of the dead*]."

CHAPTER 43

The famine was severe in the land. **2** When they had eaten up the grain which they had brought out of Egypt, their father said to them, "Go again, buy us a little more food."

3 Judah spoke to him, saying, "The man solemnly warned us, saying, 'You shall not see my face, unless your brother is with you.' **4** If you'll send our brother with us, we'll go down and buy you food, **5** but if you'll not send him, we'll not go down, for the man said to us, 'You shall not see my face, unless your brother is with you.'"

6 Israel said, "Why did you treat me so badly, telling the man that you had another brother?"

7 They said, "The man asked directly concerning ourselves, and concerning our relatives, saying, 'Is your father still alive? Have you another brother?' We just answered his questions. Is there any way we could know that he would say, 'Bring your brother down?'"

Joseph and Brethren with Corn Sacks

Flemish School

16TH CENTURY

This stained-glass window in All Saints Church in Earsham, England, shows a richly dressed Joseph standing on the left, and several of his brothers carrying sacks of corn on the right. The brothers traveled to Egypt to buy grain during a time of famine, but failed to recognize their sibling Joseph, whom they had sold into slavery years earlier.

8 Judah said to Israel, his father, "Send the boy with me, and we'll get up and go, so that we may live, and not die, both we, and you, and also our little ones. **9** I'll be collateral for him. From my hand will you require him. If I don't bring him to you, and set him before you, then let me bear the blame forever, **10** for if we hadn't delayed, surely we would have returned a second time by now."

11 Their father, Israel, said to them, "If it must be so, then do this. Take from the choice fruits of the land in your bags, and carry down a present for the man, a little balm, a little honey, spices and myrrh, nuts, and almonds; **12** and take double money in your hand, and take back the money that was returned in the mouth of your sacks. Perhaps it was an oversight. **13** Take your brother also, get up, and return to the man. **14** May God Almighty give you mercy before the man, that he may release to you your other brother and Benjamin. If I am bereaved of my children, I am bereaved."

15 The men took that present, and they took double money in their hand, and Benjamin; and got up, went down to Egypt, and stood before Joseph. **16** When Joseph saw Benjamin with them, he said to the steward of his house, "Bring the men into the house, and butcher an animal, and prepare; for the men will dine with me at noon."

17 The man did as Joseph commanded, and the man brought the men to Joseph's house. **18** The men were afraid, because they were brought to Joseph's house; and they said, "Because of the money that was returned in our sacks at the first time, we're brought in; that he may seek occasion against us, attack us, and seize us as slaves, along with our donkeys." **19** They came near to the steward of Joseph's house, and they spoke to him at the door of the house, **20** and said, "Oh, my lord, we indeed came down the first time to buy food. **21** When we came to the lodging place, we opened our sacks, and behold, each man's money was in the mouth of his sack, our money in full weight. We have brought it back in our hand. **22** We have brought down other money in our hand to buy food. We don't know who put our money in our sacks."

23 He said, "Peace be to you. Don't be afraid. Your God, and the God of your father, has given you treasure in your sacks. I received your money." He brought Simeon out to them. **24** The man brought the men into Joseph's house, and gave them water, and they washed their feet. He gave their donkeys fodder. **25** They prepared the present for Joseph's coming at noon, for they heard that they should eat bread there.

26 When Joseph came home, they brought him the present which was in their hand into the house, and bowed themselves down to him to the earth. **27** He asked them of their welfare, and said, "Is your father well, the old man of whom you spoke? Is he yet alive?" **28** They said, "Your servant, our father, is well. He is still alive." They bowed down humbly. **29** He lifted up his eyes, and saw Benjamin, his brother, his mother's son, and said, "Is this your youngest brother, of whom you spoke to me?" He said, "God be gracious to you, my son." **30** Joseph hurried, for his heart yearned over his brother; and he sought a place to weep. He entered into his room, and wept there. **31** He washed his face, and came out. He controlled himself, and said, "Serve the meal."

32 They served him by himself, and them by themselves, and the Egyptians, that ate with him, by themselves, because the Egyptians do not eat bread with the Hebrews, for that is an abomination to the Egyptians. **33** They sat before him, the firstborn according to his birthright, and the youngest according to his youth, and the men marveled one with another. **34** He sent portions to them from before him, but Benjamin's portion was five times as much as any of theirs. They drank, and were merry with him.

CHAPTER 44

He commanded the steward of his house, saying, "Fill the men's sacks with food, as much as they can carry, and put each man's money in his sack's mouth. **2** Put my cup, the silver cup, in the sack's mouth of the youngest, with his grain money." He did according to the word that Joseph had spoken. **3** As soon as the morning was light, the men were sent away, they and their donkeys. **4** When they had gone out of the city, and were not yet far off, Joseph said to his steward, "Up, follow

after the men. When you overtake them, ask them, 'Why have you rewarded evil for good? 5 Isn't this that from which my lord drinks, and by which he indeed divines? You have done evil in so doing.'" 6 He overtook them, and he spoke these words to them.

7 They said to him, "Why does my lord speak such words as these? Far be it from your servants that they should do such a thing! 8 Behold, the money, which we found in our sacks' mouths, we brought again to you out of the land of Canaan. How then should we steal silver or gold out of your lord's house? 9 With whomever of your servants it is found, let him die, and we also will be my lord's slaves."

10 He said, "Now also let it be according to your words: he with whom it is found will be my slave; and you will be blameless."

11 Then they hurried, and each man took his sack down to the ground, and each man opened his sack. 12 He searched, beginning with the oldest, and ending at the youngest. The cup was found in Benjamin's sack. 13 Then they tore their clothes, and each man loaded his donkey, and returned to the city.

14 Judah and his brothers came to Joseph's house, and he was still there. They fell on the ground before him. 15 Joseph said to them, "What deed is this that you have done? Don't you know that such a man as I can indeed divine?"

16 Judah said, "What will we tell my lord? What will we speak? Or how will we clear ourselves? God has found out the iniquity of your servants. Behold, we are my lord's slaves, both we, and he also in whose hand the cup is found."

17 He said, "Far be it from me that I should do so. The man in whose hand the cup is found, he will be my slave; but as for you, go up in peace to your father."

18 Then Judah came near to him, and said, "Oh, my lord, please let your servant speak a word in my lord's ears, and don't let your anger burn against your servant; for you are even as Pharaoh. 19 My lord asked his servants, saying, 'Have you a father, or a brother?' 20 We said to my lord, 'We have a father, an old man, and a child of his old age, a little one; and his brother is dead, and he alone is left of his mother; and his father loves him.' 21 You said to your servants, 'Bring him down to me, that I may set my eyes on him.' 22 We said to my lord, 'The boy can't leave his father: for if he

should leave his father, his father would die.' 23 You said to your servants, 'Unless your youngest brother comes down with you, you will see my face no more.' 24 When we came up to your servant my father, we told him the words of my lord. 25 Our father said, 'Go again, buy us a little food.' 26 We said, 'We can't go down. If our youngest brother is with us, then we will go down: for we may not see the man's face, unless our youngest brother is with us.' 27 Your servant, my father, said to us, 'You know that my wife bore me two sons: 28 and the one went out from me, and I said, "Surely he is torn in pieces"; and I haven't seen him since. 29 If you take this one also from me, and harm happens to him, you will bring down my gray hairs with sorrow to Sheol [*the place of the dead*].' 30 Now therefore when I come to your servant my father, and the boy is not with us; since his life is bound up in the boy's life; 31 it will happen, when he sees that the boy is no more, that he will die. Your servants will bring down the gray hairs of your servant, our father, with sorrow to Sheol. 32 For your servant became collateral for the boy to my father, saying, 'If I don't bring him to you, then I will bear the blame to my father forever.' 33 Now therefore, please let your servant stay instead of the boy, my lord's slave; and let the boy go up with his brothers. 34 For how will I go up to my father, if the boy isn't with me?—lest I see the evil that will come on my father."

OVERLEAF: **The Search for the Cup (left) and the Discovery of the Stolen Cup (right)**

Francesco Bacchiacca
1515–16
These two panels from the *Scenes from the Story of Joseph* series depict the story of the stolen cup. After allowing his brothers to pack up their belongings and leave Egypt to return home to Canaan, Joseph instructed a servant to hide a silver cup in his brother Benjamin's bag. He then used the "stolen" cup as an excuse to detain the brothers.

CHAPTERS 45–47

Joseph finally reveals his true identity to his brothers, then sends for their father Jacob and their families to be brought back to Egypt to live in prosperity with him. Jacob and the whole family travel to Goshen in Egypt, where Joseph and his father are finally reunited. Joseph presents his father to Pharaoh, who guarantees safety and prosperity for them all. Meanwhile, Joseph reduces most of the Egyptians to permanent serfdom.

CHAPTER 45

Then Joseph couldn't control himself before all those who stood before him, and he cried, "Cause everyone to go out from me!" No one else stood with him, while Joseph made himself known to his brothers. **2** He wept aloud. The Egyptians heard, and the house of Pharaoh heard. **3** Joseph said to his brothers, "I am Joseph! Does my father still live?"

His brothers couldn't answer him; for they were terrified at his presence. **4** Joseph said to his brothers, "Come near to me, please."

They came near. "He said, I am Joseph, your brother, whom you sold into Egypt. **5** Now don't be grieved, nor angry with yourselves, that you sold me here, for God sent me before you to preserve life. **6** For these two years the famine has been in the land, and there are yet five years, in which there will be no plowing and no harvest. **7** God sent me before you to preserve for you a remnant in the earth, and to save you alive by a great deliverance. **8** So now it wasn't you who sent me here, but God, and he has made me a father to Pharaoh, lord of all his house, and ruler over all the land of Egypt. **9** Hurry, and go up to my father, and tell him, 'This is what your son Joseph says, "God has made me lord of all Egypt. Come down to me. Don't wait. **10** You shall dwell in the land of Goshen, and you will be near to me, you, your children, your children's children, your flocks, your herds, and all that you have. **11** There I will nourish you; for there are yet five years of famine; lest you come to poverty, you, and your household, and all that you have."' **12** Behold, your eyes see, and the eyes of my brother Benjamin, that it is my mouth that speaks to you. **13** You shall tell my father of all my glory in Egypt, and of all that you have seen. You shall hurry and bring my father down here." **14** He fell on his brother Benjamin's neck, and wept, and Benjamin wept on his neck. **15** He kissed all his brothers, and wept on them. After that his brothers talked with him.

16 The report of it was heard in Pharaoh's house, saying, "Joseph's brothers have come." It pleased Pharaoh well, and his servants. **17** Pharaoh said to Joseph, "Tell your brothers, 'Do this. Load your animals, and go, travel to the land of Canaan. **18** Take your father and your households, and come to me, and I will give you the good of the land of Egypt, and you will eat the fat of the land.' **19** Now you are commanded: do this. Take wagons out of the land of Egypt for your little ones, and for your wives, and bring your father, and come. **20** Also, don't concern yourselves about your belongings, for the good of all the land of Egypt is yours."

OVERLEAF: Joseph Recognized by His Brothers

François Gérard
1789

Joseph, standing on the left wearing an Egyptian headdress, reveals his true identity to his shocked brothers. Benjamin, the youngest brother, reaches up to embrace Joseph.

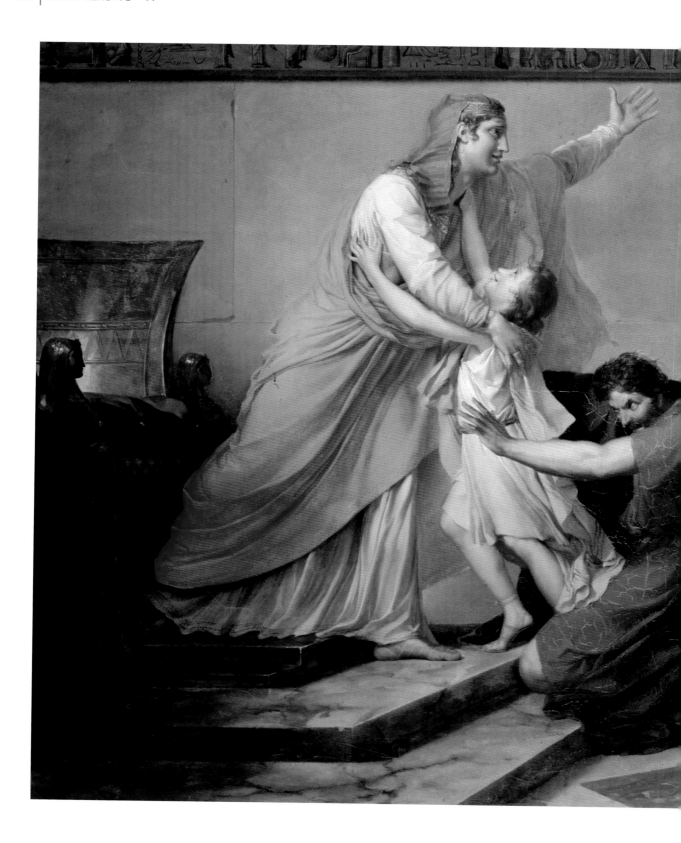

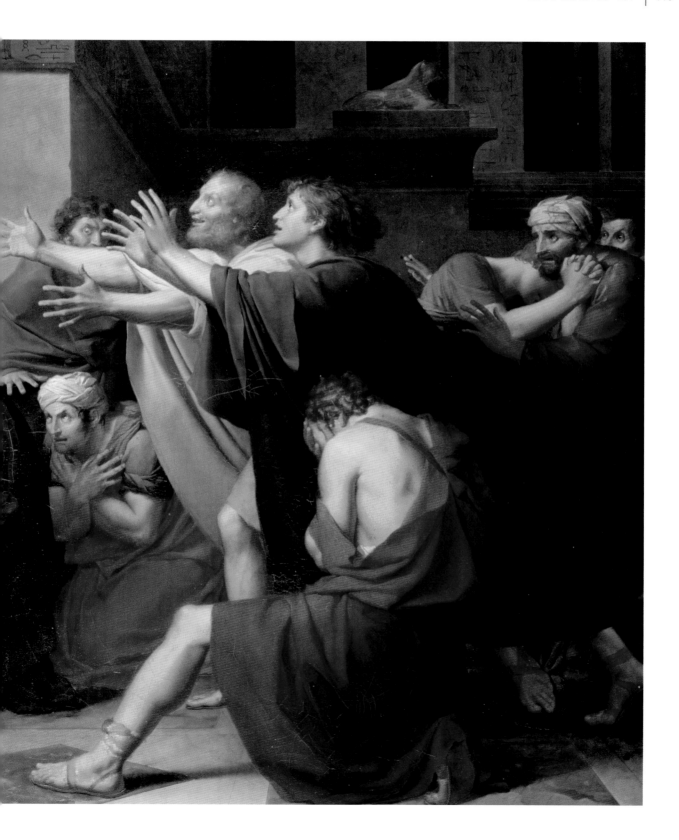

21 The sons of Israel did so. Joseph gave them wagons, according to the commandment of Pharaoh, and gave them provision for the way. 22 He gave each one of them changes of clothing, but to Benjamin he gave three hundred pieces of silver and five changes of clothing. 23 He sent the following to his father: ten donkeys loaded with the good things of Egypt, and ten female donkeys loaded with grain and bread and provision for his father by the way. 24 So he sent his brothers away, and they departed. He said to them, "See that you don't quarrel on the way."

25 They went up out of Egypt, and came into the land of Canaan, to Jacob their father. 26 They told him, saying, "Joseph is still alive, and he is ruler over all the land of Egypt." His heart fainted, for he didn't believe them. 27 They told him all the words of Joseph, which he had said to them. When he saw the wagons which Joseph had sent to carry him, the spirit of Jacob, their father, revived. 28 Israel said, "It is enough. Joseph my son is still alive. I will go and see him before I die."

CHAPTER 46

Israel traveled with all that he had, and came to Beersheba, and offered sacrifices to the God of his father, Isaac. 2 God spoke to Israel in the visions of the night, and said, "Jacob, Jacob!"

He said, "Here I am."

3 He said, "I am God, the God of your father. Don't be afraid to go down into Egypt, for there I will make of you a great nation. 4 I will go down with you into Egypt. I will also surely bring you up again. Joseph will close your eyes."

5 Jacob rose up from Beersheba, and the sons of Israel carried Jacob, their father, their little ones, and their wives, in the wagons which Pharaoh had sent to carry him. 6 They took their livestock, and their goods, which they had gotten in the land of Canaan, and came into Egypt—Jacob, and all his offspring with him, 7 his sons, and his sons' sons with him, his daughters, and his sons' daughters, and he brought all his offspring with him into Egypt.

8 These are the names of the children of Israel, who came into Egypt, Jacob and his sons: Reuben, Jacob's firstborn. 9 The sons of Reuben: Hanoch, Pallu, Hezron, and Carmi. 10 The sons of Simeon: Jemuel, Jamin, Ohad, Jachin, Zohar, and Shaul the son of a Canaanite woman. 11 The sons of Levi: Gershon, Kohath, and Merari. 12 The sons of Judah: Er, Onan, Shelah, Perez, and Zerah; but Er and Onan died in the land of Canaan. The sons of Perez were Hezron and Hamul. 13 The sons of Issachar: Tola, Puvah, Iob, and Shimron. 14 The sons of Zebulun: Sered, Elon, and Jahleel. 15 These are the sons of Leah, whom she bore to Jacob in Paddan Aram, with his daughter Dinah. All the souls of his sons and his daughters were thirty-three. 16 The sons of Gad: Ziphion, Haggi, Shuni, Ezbon, Eri, Arodi, and Areli. 17 The sons of Asher: Imnah, Ishvah, Ishvi, Beriah, and Serah their sister. The sons of Beriah: Heber and Malchiel. 18 These are the sons of Zilpah, whom Laban gave to Leah, his daughter, and these she bore to Jacob, even sixteen souls. 19 The sons of Rachel, Jacob's wife: Joseph and Benjamin. 20 To Joseph in the land of Egypt were born Manasseh and Ephraim, whom Asenath, the daughter of Potiphera, priest of On, bore to him. 21 The sons of Benjamin: Bela, Becher, Ashbel, Gera, Naaman, Ehi, Rosh, Muppim, Huppim, and Ard. 22 These are the sons of

Jacob Goes into Egypt

Gustave Doré
19TH CENTURY

Jacob, seated on a camel at the top of the engraving, traveled from Beersheba to Egypt to be with his son Joseph. Surrounding Jacob are other members of his family and all their goods and livestock. There is some discrepancy in the biblical account over the exact number, but approximately seventy male descendants of Jacob went to live in Egypt, together with all of their wives and daughters.

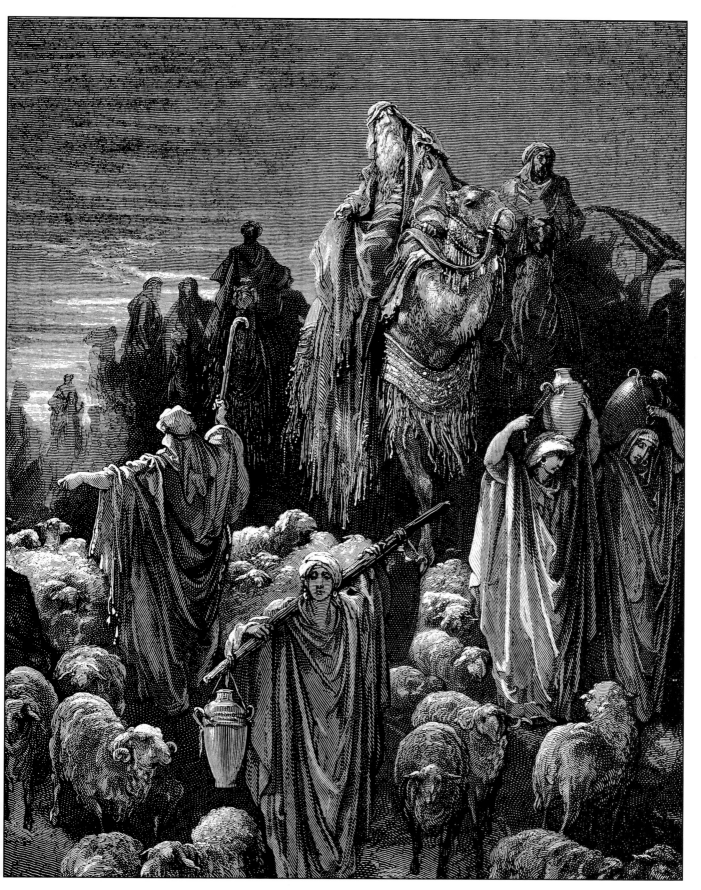

> *He [Jacob/Israel] sent Judah before him to Joseph, to show the way before him to Goshen, and they came into the land of Goshen. Joseph prepared his chariot, and went up to meet Israel, his father, in Goshen. He presented himself to him, and fell on his neck, and wept on his neck a good while. Israel said to Joseph, "Now let me die, since I have seen your face, that you are still alive."*
>
> Genesis 46:28–30

Rachel, who were born to Jacob: all the souls were fourteen. **23** The son of Dan: Hushim. **24** The sons of Naphtali: Jahzeel, Guni, Jezer, and Shillem. **25** These are the sons of Bilhah, whom Laban gave to Rachel, his daughter, and these she bore to Jacob: all the souls were seven. **26** All the souls who came with Jacob into Egypt, who were his direct offspring, besides Jacob's sons' wives, all the souls were sixty-six. **27** The sons of Joseph, who were born to him in Egypt, were two souls. All the souls of the house of Jacob, who came into Egypt, were seventy.

28 He sent Judah before him to Joseph, to show the way before him to Goshen, and they came into the land of Goshen. **29** Joseph prepared his chariot, and went up to meet Israel, his father, in Goshen. He presented himself to him, and fell on his neck, and wept on his neck a good while. **30** Israel said to Joseph, "Now let me die, since I have seen your face, that you are still alive."

31 Joseph said to his brothers, and to his father's house, "I will go up, and speak with Pharaoh, and will tell him, 'My brothers, and my father's house, who were in the land of Canaan, have come to me. **32** These men are shepherds, for they have been keepers of livestock, and they have brought their flocks, and their herds, and all that they have.' **33** It will happen, when Pharaoh summons you, and will say, 'What is your occupation?' **34** that you shall say, 'Your servants have been keepers of livestock from our youth even until now, both we, and our fathers,' that you may dwell in the land of Goshen; for every shepherd is an abomination to the Egyptians."

CHAPTER 47

Then Joseph went in and told Pharaoh, and said, "My father and my brothers, with their flocks, their herds, and all that they own, have come out of the land of Canaan; and behold, they are in the land of Goshen." **2** From among his brothers he took five men, and presented them to Pharaoh. **3** Pharaoh said to his brothers, "What is your occupation?"

They said to Pharaoh, "Your servants are shepherds, both we, and our fathers." **4** They said to Pharaoh, "We have come to

live as foreigners in the land, for there is no pasture for your servants' flocks. For the famine is severe in the land of Canaan. Now therefore, please let your servants dwell in the land of Goshen."

⁵ Pharaoh spoke to Joseph, saying, "Your father and your brothers have come to you. ⁶ The land of Egypt is before you. Make your father and your brothers dwell in the best of the land. Let them dwell in the land of Goshen. If you know any able men among them, then put them in charge of my livestock."

⁷ Joseph brought in Jacob, his father, and set him before Pharaoh, and Jacob blessed Pharaoh. ⁸ Pharaoh said to Jacob, "How many are the days of the years of your life?"

⁹ Jacob said to Pharaoh, "The days of the years of my pilgrimage are one hundred thirty years. Few and evil have been the days of the years of my life, and they have not attained to the days of the years of the life of my fathers in the days of their pilgrimage." ¹⁰ Jacob blessed Pharaoh, and went out from the presence of Pharaoh.

¹¹ Joseph placed his father and his brothers, and gave them a possession in the land of Egypt, in the best of the land, in the land of Rameses, as Pharaoh had commanded. ¹² Joseph nourished his father, his brothers, and all of his father's household, with bread, according to their families.

¹³ There was no bread in all the land; for the famine was very severe, so that the land of Egypt and the land of Canaan fainted by reason of the famine. ¹⁴ Joseph gathered up all the money that was found in the land of Egypt, and in the land of Canaan, for the grain which they bought: and Joseph brought the money into Pharaoh's house. ¹⁵ When the money was all spent in the land of Egypt, and in the land of Canaan, all the Egyptians came to Joseph, and said, "Give us bread, for why should we die in your presence? For our money fails."

¹⁶ Joseph said, "Give me your livestock; and I will give you food for your livestock, if your money is gone."

¹⁷ They brought their livestock to Joseph, and Joseph gave them bread in exchange for the horses, and for the flocks, and for the herds, and for the donkeys: and he fed them with bread in exchange for all their livestock for that year. ¹⁸ When that year was ended, they came to him the second year, and said to him, "We will not hide from my lord how our money is all spent, and the herds of livestock are my lord's. There is nothing left in the sight of my lord, but our bodies, and our lands. ¹⁹ Why should we die before your eyes, both we and our land? Buy us and our land for bread, and we and our land will be servants to Pharaoh. Give us seed, that we may live, and not die, and that the land won't be desolate."

²⁰ So Joseph bought all the land of Egypt for Pharaoh, for every man of the Egyptians sold his field, because the famine was severe on them, and the land became Pharaoh's. ²¹ As for the people, he moved them to the cities from one end of the border of Egypt even to the other end of it. ²² Only he didn't buy the land of the priests, for the priests had a portion from Pharaoh, and ate their portion which Pharaoh gave them. That is why they did not sell their land. ²³ Then Joseph said to the people, "Behold, I have bought you and your land today for Pharaoh. Behold, here is seed for you, and you shall sow the land. ²⁴ It will happen at the harvests, that you shall give a fifth to Pharaoh, and four parts will be your own, for seed of the field, for your food, for them of your households, and for food for your little ones."

²⁵ They said, "You have saved our lives! Let us find favor in the sight of my lord, and we will be Pharaoh's servants."

²⁶ Joseph made it a statute concerning the land of Egypt to this day, that Pharaoh should have the fifth. Only the land of the priests alone did not become Pharaoh's.

²⁷ Israel lived in the land of Egypt, in the land of Goshen; and they got themselves possessions therein, and were fruitful, and multiplied exceedingly. ²⁸ Jacob lived in the land of Egypt seventeen years. So the days of Jacob, the years of his life, were one hundred forty-seven years. ²⁹ The time came near that Israel must die, and he called his son Joseph, and said to him, "If now I have found favor in your sight, please put your hand under my thigh, and deal kindly and truly with me. Please don't bury me in Egypt, ³⁰ but when I sleep with my fathers, you shall carry me out of Egypt, and bury me in their burying place."

He said, "I will do as you have said."

³¹ He said, "Swear to me," and he swore to him. Israel bowed himself on the bed's head.

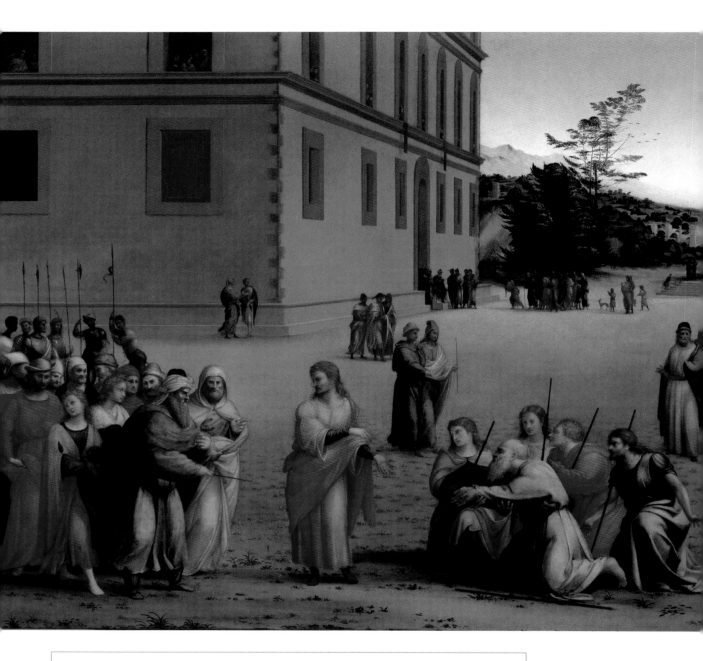

Joseph Presents His Father and Brothers to the Pharaoh

Francesco Granacci
c. 1515

Pharaoh stands on the left of the painting at the front of an entourage, while Joseph presents his father and some of his brothers to Pharaoh, who kneel before the Egyptian ruler. Pharaoh promised them their safety and prosperity, and Jacob blessed Pharaoh in return.

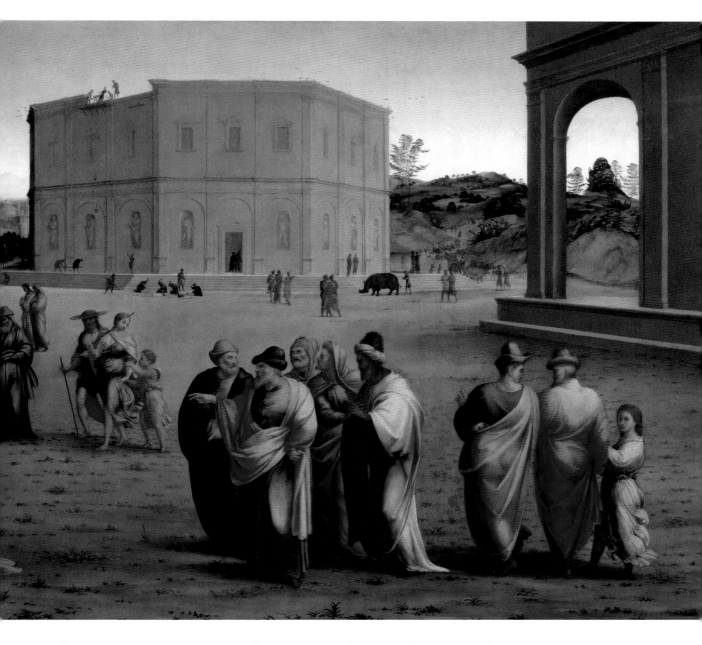

Pharaoh spoke to Joseph, saying, "Your father and your brothers have come to you. The land of Egypt is before you. Make your father and your brothers dwell in the best of the land. Let them dwell in the land of Goshen."

Genesis 47:5–6

CHAPTERS 48–50

A dying Jacob adopts and blesses his grandsons Manasseh and Ephraim (the two sons of Joseph), but gives the traditional blessing of the firstborn to the younger Ephraim instead of the older Manasseh. Jacob then pronounces a blessing on each of his own twelve sons. Just before his death, he asks to be buried in Abraham's tomb in Hebron. After seventy days of official mourning, Joseph, his brothers, and representatives of Pharaoh take Jacob's body to Hebron and bury it. Joseph dies at the age of 110.

CHAPTER 48

After these things, someone said to Joseph, "Behold, your father is sick." He took with him his two sons, Manasseh and Ephraim. ² Someone told Jacob, and said, "Behold, your son Joseph comes to you," and Israel strengthened himself, and sat on the bed. ³ Jacob said to Joseph, "God Almighty appeared to me at Luz in the land of Canaan, and blessed me, ⁴ and said to me, 'Behold, I will make you fruitful, and multiply you, and I will make of you a company of peoples, and will give this land to your offspring after you for an everlasting possession.' ⁵ Now your two sons, who were born to you in the land of Egypt before I came to you into Egypt, are mine; Ephraim and Manasseh, even as Reuben and Simeon, will be mine. ⁶ Any children whom you become the father of after them will be yours. They will be called after the name of their brothers in their inheritance. ⁷ As for me, when I came from Paddan, Rachel died by me in the land of Canaan on the way, when there was still some distance to come to Ephrath, and I buried her there on the way to Ephrath (also called Bethlehem)."

⁸ Israel saw Joseph's sons, and said, "Who are these?"

⁹ Joseph said to his father, "They are my sons, whom God has given me here."

He said, "Please bring them to me, and I will bless them." ¹⁰ Now the eyes of Israel were dim with age, so that he could not see. He brought them near to him; and he kissed them, and embraced them. ¹¹ Israel said to Joseph, "I didn't think I would see your face, and behold, God has let me see your offspring also." ¹² Joseph brought them out from between his knees, and he bowed himself with his face to the earth. ¹³ Joseph took them both, Ephraim in his right hand toward Israel's left hand, and Manasseh in his left hand toward Israel's right hand, and brought them near to him. ¹⁴ Israel stretched out his right hand, and laid it on Ephraim's head, who was the younger, and his left hand on Manasseh's head, guiding his hands knowingly, for Manasseh was the firstborn. ¹⁵ He blessed Joseph, and said, "The God before whom my fathers Abraham and Isaac walked, the God who has fed me all my life long to this day, ¹⁶ the angel who has redeemed me from all evil, bless the lads, and let my name be named on them, and the name of my fathers Abraham and Isaac. Let them grow into a multitude upon the earth."

¹⁷ When Joseph saw that his father laid his right hand on the head of Ephraim, it displeased him. He held up his father's hand, to remove it from Ephraim's head to Manasseh's head. ¹⁸ Joseph said to his father, "Not so, my father; for this is the firstborn; put your right hand on his head."

¹⁹ His father refused, and said, "I know, my son, I know. He also will become a people, and he also will be great. However, his younger brother will be greater than he, and his offspring will become a multitude of nations." ²⁰ He blessed them that day, saying, "In you will Israel bless, saying, 'God make you as Ephraim and as Manasseh'" He set Ephraim before Manasseh. ²¹ Israel said to Joseph, "Behold, I am dying, but God will be with you, and bring you again to the land of your fathers. ²² Moreover I have given to you one portion above your brothers, which I took out of the hand of the Amorite with my sword and with my bow."

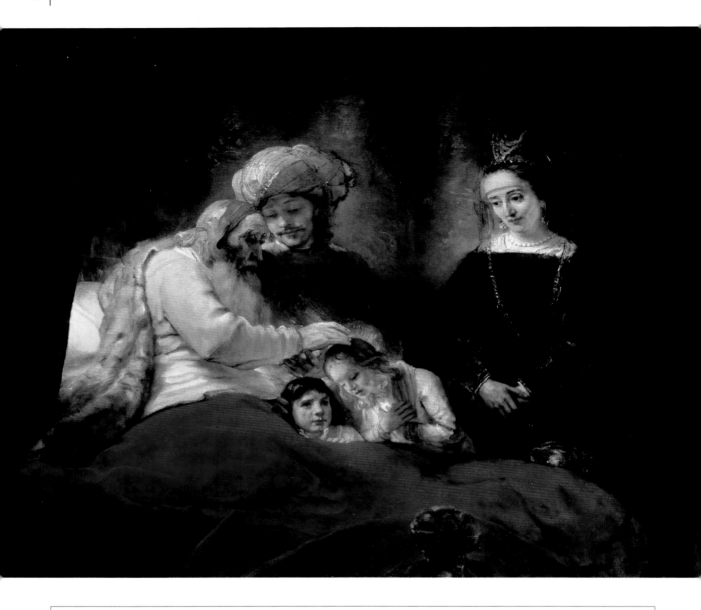

Jacob Blessing the Sons of Joseph

Rembrandt van Rijn

1656

Joseph looks on as his dying father Jacob blesses Joseph's two sons. Jacob is using his right hand to bless the younger Ephraim, rather than giving this traditional blessing of the firstborn to the older Manasseh. Rembrandt includes Joseph's wife Asenath in the scene, although she is not mentioned as being present in the biblical account.

The ancient nation of Israel was composed of twelve tribes descended from the twelve sons of Jacob (who was given the name Israel by God in Genesis 32:28). When the Promised Land of Canaan was divided among the tribes in the time of Joshua, the Levites (descendants of Jacob's son Levi) were excluded because they had become priests. To maintain the original number of tribal units, the tribe of Joseph was split into two, based on Joseph's sons Ephraim and Manasseh. The tribe of Ephraim became more prominent and numerous than that of Manasseh, reflecting Jacob's blessing.

CHAPTER 49

Jacob called to his sons, and said:
"Gather yourselves together, that I may
tell you that which will happen to you
in the days to come.

2 Assemble and hear, you sons of Jacob.
Listen to Israel, your father.

3 "Reuben, you are my firstborn,
my might, and the beginning of my strength;
excelling in dignity, and excelling in power.

4 Boiling over like water, you shall not excel;
because you went up to your father's bed,
then defiled it. He went up to my couch.

5 "Simeon and Levi are brothers.
Their swords are weapons of violence.

6 My soul, don't come into their council.
My glory, don't be united to their assembly;
for in their anger they killed men.
In their self-will they hamstrung cattle.

7 Cursed be their anger, for it was fierce;
and their wrath, for it was cruel.
I will divide them in Jacob,
and scatter them in Israel.

8 "Judah, your brothers will praise you.
Your hand will be on the neck of your enemies.
Your father's sons will bow down before you.

9 Judah is a lion's cub.
From the prey, my son, you have gone up.
He stooped down, he crouched as a lion,
as a lioness—who will rouse him up?

10 The scepter will not depart from Judah,
nor the ruler's staff from between his feet,
until he comes to whom it belongs.
To him will the obedience of the peoples be.

11 Binding his foal to the vine,
his donkey's colt to the choice vine;
he has washed his garments in wine,
his robes in the blood of grapes.

12 His eyes will be red with wine,
his teeth white with milk.

13 "Zebulun will dwell at the haven of the sea.
He will be for a haven of ships.
His border will be on Sidon.

14 "Issachar is a strong donkey,
lying down between the saddlebags.

15 He saw a resting place, that it was good,
the land, that it was pleasant.
He bows his shoulder to the burden,
and becomes a servant doing forced labor.

16 "Dan will judge his people,
as one of the tribes of Israel.

17 Dan will be a serpent on the trail,
an adder in the path,
That bites the horse's heels,
so that his rider falls backward.

18 I have waited for your salvation, the LORD.

19 "A troop will press on Gad,
but he will press on their heel.

20 "Asher's food will be rich.
He will produce royal dainties.

21 "Naphtali is a doe set free,
who bears beautiful fawns.

22 "Joseph is a fruitful vine,
a fruitful vine by a spring.
His branches run over the wall.

23 The archers have severely grieved him,
shot at him, and persecute him:

24 But his bow remained strong.
The arms of his hands were made strong,
by the hands of the Mighty One of Jacob,
(from there is the shepherd, the stone of Israel),

25 even by the God of your father, who will help you;
by the Almighty, who will bless you,
with blessings of heaven above,
blessings of the deep that lies below,
blessings of the breasts, and of the womb.

26 The blessings of your father have prevailed
above the blessings of your ancestors,
above the boundaries of the ancient hills.
They will be on the head of Joseph,
on the crown of the head of him who is separated
from his brothers.

27 "Benjamin is a ravenous wolf.
In the morning he will devour the prey.
At evening he will divide the plunder."

28 All these are the twelve tribes of Israel, and
this is what their father spoke to them and
blessed them. He blessed everyone according
to his blessing. 29 He instructed them, and
said to them, "I am to be gathered to my
people. Bury me with my fathers in the cave
that is in the field of Ephron the Hittite,
30 in the cave that is in the field of Machpelah,
which is before Mamre, in the land of Canaan,
which Abraham bought with the field from
Ephron the Hittite as a burial place. 31 There
they buried Abraham and Sarah, his wife.
There they buried Isaac and Rebekah, his wife,

and there I buried Leah: 32 the field and the cave that is therein, which was purchased from the children of Heth." 33 When Jacob finished charging his sons, he gathered up his feet into the bed, and yielded up the spirit, and was gathered to his people.

CHAPTER 50

Joseph fell on his father's face, wept on him, and kissed him. 2 Joseph commanded his servants, the physicians, to embalm his father; and the physicians embalmed Israel. 3 Forty days were fulfilled for him, for that is how many the days it takes to embalm. The Egyptians wept for him for seventy days.

4 When the days of weeping for him were past, Joseph spoke to the house of Pharaoh, saying, "If now I have found favor in your eyes, please speak in the ears of Pharaoh, saying, 5 'My father made me swear, saying, "Behold, I am dying. Bury me in my grave which I have dug for myself in the land of Canaan." Now therefore, please let me go up and bury my father, and I will come again.'"

6 Pharaoh said, "Go up, and bury your father, just like he made you swear."

7 Joseph went up to bury his father; and with him went up all the servants of Pharaoh, the elders of his house, all the elders of the land of Egypt, 8 All the house of Joseph, his brothers, and his father's house. Only their little ones, their flocks, and their herds, they left in the land of Goshen. 9 There went up with him both chariots and horsemen. It was a very great company. 10 They came to the threshing floor of Atad, which is beyond the Jordan, and there they lamented with a very great and severe lamentation. He mourned for his father seven days. 11 When the inhabitants of the land, the Canaanites, saw the mourning in the floor of Atad, they said, "This is a grievous mourning by the Egyptians." Therefore its name was called Abel Mizraim, which is beyond the Jordan. 12 His sons did to him just as he commanded them, 13 for his sons carried him into the land of Canaan, and buried him in the cave of the field of Machpelah, which Abraham bought with the field, for a possession of a burial site, from Ephron the Hittite, before Mamre. 14 Joseph returned into Egypt—he, and his brothers, and all that went up with him to bury his father, after he had buried his father.

15 When Joseph's brothers saw that their father was dead, they said, "It may be that Joseph will hate us, and will fully pay us back for all the evil which we did to him." 16 They sent a message to Joseph, saying, "Your father commanded before he died, saying, 17 'You shall tell Joseph, "Now please forgive the disobedience of your brothers, and their sin, because they did evil to you."' Now, please forgive the disobedience of the servants of the God of your father." Joseph wept when they spoke to him. 18 His brothers also went and fell down before his face; and they said, "Behold, we are your servants." 19 Joseph said to them, "Don't be afraid, for am I in the place of God? 20 As for you, you meant evil against me, but God meant it for good, to bring to pass, as it is today, to save many people alive. 21 Now therefore don't be afraid. I will nourish you and your little ones." He comforted them, and spoke kindly to them.

22 Joseph lived in Egypt, he, and his father's house. Joseph lived one hundred ten years. 23 Joseph saw Ephraim's children to the third generation. The children also of Machir, the son of Manasseh, were born on Joseph's knees. 24 Joseph said to his brothers, "I am dying, but God will surely visit you, and bring you up out of this land to the land which he swore to Abraham, to Isaac, and to Jacob." 25 Joseph took an oath of the children of Israel, saying, "God will surely visit you, and you shall carry up my bones from here." 26 So Joseph died, being one hundred ten years old, and they embalmed him, and he was put in a coffin in Egypt.

The Patriarchs and Founders of the Twelve Tribes of Israel

Joshua Price
1735

The upper portion of the West Window of Westminster Abbey in London, England, shows key figures from Genesis. The top row depicts the three patriarchs of Israel: Abraham, Isaac, and Jacob. The lower two rows feature the twelve sons of Jacob, from whom the twelve tribes of Israel were descended, plus Moses and his brother Aaron (the two figures at bottom right) from later books of the Old Testament.

INDEX

CREDITS

Quarto would like to acknowledge the following for supplying images reproduced in this book:

Alamy: The Art Archive *pages 6, 32–3, 42, 50, 57, 58–9, 60, 76–7 & 81*; SuperStock *page 13*; The Print Collector *pages 26 & 35*; The Artchives *page 38*; PAINTING *page 64*; Holmes Garden Photos *page 105*; The Art Gallery Collection *pages 112–13*; Angelo Hornak *page 125*

The Art Archive: Superstock *page 73*

Corbis Images: Alinari Archives *pages 10 & 118–19*; Fine Art Photographic Library *pages 22–3*; The Gallery Collection *page 67*; Arte & Immagini srl *pages 88–9*; Christie's Images *pages 100–1*

Getty Images: De Agostini *pages 2, 16–17, 20, 25, 28–9, 44, 70, 96–7, 108–9 & 122*; The Bridgeman Art Library *pages 48–9*; British Library/Robana *page 85*; SuperStock *pages 92–3*

Shutterstock: jorisvo *page 1*; Ajay Shrivastava *page 3 (cross used throughout book)*; Pack-Shot *page 4*; Nella *pages 4–7 & 126–8 (patterned background papers)*

All other photographs and illustrations are the copyright of Quarto Publishing plc. While every effort has been made to credit contributors, Quarto would like to apologize should there have been any errors or omissions—and would be pleased to make the appropriate correction for future editions of the book.